This book is dedicated with deepest appreciation to the memory of

THEODORE LAKIN STEELE
(1905-1995)

Grandson of the artist, "Ted" Steele was throughout his life a proud and constant standard-bearer for the work of his distinguished grandfather. He is the author of Part I of the biography of T.C. Steele, *The House of the Singing Winds.* He was executor for the estates of a number of family members and tirelessly organized The Steele Papers to ensure the family's continuing involvement in their heritage and to provide art historians and museum curators with a primary source for research.

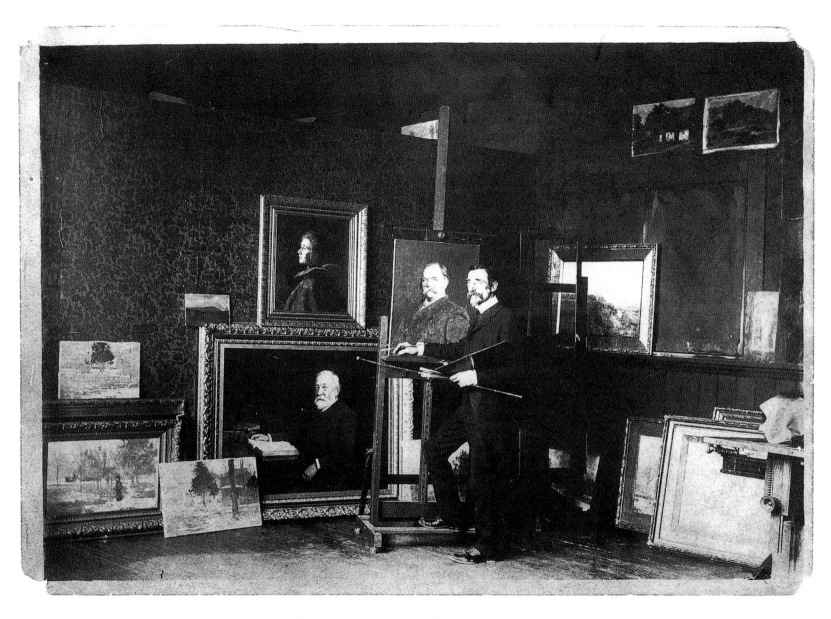

T. C. STEELE IN HIS TINKER PLACE STUDIO, c. 1901
The Steele Papers, Archives of American Art, Smithsonian Institution, Washington, DC

THEODORE CLEMENT STEELE
An American Master of Light

TEXT BY WILLIAM H. GERDTS

PUBLISHED IN ASSOCIATION WITH
EVANSVILLE MUSEUM OF ARTS & SCIENCE, EVANSVILLE, INDIANA

CHAMELEON BOOKS, INC., NEW YORK, NEW YORK

This book and the attendant exhibition,
"Theodore Clement Steele: An American Master of Light,"
organized by the Evansville Museum of Arts & Science,
were made possible by generous grants from:

ARVIN FOUNDATION
PSI ENERGY through THE CINergy FOUNDATION, Inc.
in cooperation with
MR. AND MRS. ROBERT HAAN
MR. AND MRS. ANDREW PAINE
and
ELAINE EWING FESS AND STEPHEN W. FESS
EVANSVILLE MUSEUM GUILD

Published by Chameleon Books, Inc.
211 West 20th Street
New York, N.Y. 10011

Production director/designer: Arnold Skolnick
Editorial director: Marion E. Wheeler
Printed and bound by O. G. Printing Productions, Ltd., Hong Kong

Published in association with Evansville Museum of Arts & Science
411 S. E. Riverside Drive
Evansville, IN 47713

Library of Congress Cataloging-in-Publication Data

Gerdts, William H.
 Theodore Clement Steele. an American master of light / text by
William H. Gerdts
 p. cm.
 Catalog of an exhibition held at the Valparaiso University Museum
of Art,. Dec. 10, 1995–Feb. 4, 1996 and at other locations.
 "Published in association with Evansville Museum of Arts & Science,
Evansville, Indiana."
 Includes bibliographical references.
 ISBN 0-915829-66-5
 1. Steele, Theodore Clement, 1847-1926—Exhibitions. 2. Light in
art—Exhibitions. 3. Impressionism (Art)—United States—Exhibitions.
 I. Steele, Theodore Clement, 1847-1926.
II. Valparaiso University. Museum of Art. III. Evansville Museum of
Arts & Science. IV. Title.
ND237. S68A4 1995
759. 13—dc20 95-40830
 CIP

DATES OF THE EXHIBITION

Valparaiso University Museum of Art
Valparaiso, Indiana
December 10, 1995—February 4, 1996

Evansville Museum of Arts & Science
Evansville, Indiana
February 18—March 31, 1996

Georgia Museum of Art, University of Georgia
Athens, Georgia
May 4—June 16, 1996

Indiana University Art Museum
Bloomington, Indiana
August 4—September 29, 1996

National Academy of Design
New York, New York
January 12—March 9, 1997

LENDERS TO THE EXHIBITION

Eckert Fine Art, Indianapolis, Indiana

Mr. and Mrs. James W. Emison III

Evansville Museum of Arts & Science

Elaine Ewing Fess and Stephen W. Fess

George Koch Sons, Inc.

Bob and Ellie Haan

Mr. and Mrs. Wade C. Harrison

Eugene and Mary L. Henderson

Mark and Carmen Holeman

Indiana State Museum and Historic Sites

Indiana University Auditorium, The Dailey Family Collection of Hoosier Art

Indianapolis Museum of Art, Gift of Mrs. William B. Wheelock

National Academy of Design

Jane and Andrew Paine

Private Collectors

Dana Reihman and Eileen Cravens

Dr. Brandt F. Steele

Jane Deuber Villacres

CONTENTS

ACKNOWLEDGMENTS

A number of friends have joined hands with the Evansville Museum to realize the dream of many years to organize a major touring exhibition of the paintings of Theodore Clement Steele and to publish a book providing an enduring visual documentary of the work of this remarkable American artist.

First of all, we would like to thank Jane and Henry Eckert of Indianapolis, whose caring and informed support were invaluable during the complex process of selecting and documenting works to be included.

We are deeply indebted to longtime friend of Indiana art Dr. William H. Gerdts, Professor of Art History, Graduate School of the City University of New York, for his insightful essay and constant support.

From the outset, the artist's heirs—most especially his great-great-grandson and Steele family archivist Thomas Lakin Creveling, who contributed the biographical notes for this book—have enthusiastically encouraged the project and most generously made available to us key information.

With the completion of our fifth book published in cooperation with Chameleon Books, Inc., we recognize the singular creative gifts of designer Arnold Skolnick and editor Marion E. Wheeler.

To the Museum's Board of Trustees and staff—especially Jon Goldman and Carol Abrams, successive Presidents; Mary McNamee Schnepper, Curator of Collections; Susan Colaricci Sauls and Todd Topper, Registrars; Thomas R. Lonnberg, Assistant Curator of Collections; Robert Swaney and Jane Ress Kline, Directors of Development; Karen Reis, Supervisor for Administrative Services/Executive Secretary; and Inez Waddle, Bookkeeper—we offer our thanks for their abiding commitment to this project.

Finally, we acknowledge with deepest appreciation the generosity of the project's sponsors and the lenders to the exhibition, who readily shared their resources and their treasures.

J.W.S. III

FOREWORD

In the eulogy delivered at T. C. Steele's memorial service at All Saints Unitarian Church in Indianapolis on September 12, 1926, the Reverend Frank C. S. Wicks spoke of the close connection between the soul of the artist and his art:

> *No artist paints the thing as it is, but only its reflection in his soul, so that the mind and character of the painter are really revealed. That accounts for the loveliness, purity and veracity of Steele's work.*

Perhaps it is the veracity of this remarkable artist's painting—his poet's gift for seeing clearly—that has drawn successive generations to it. Describing a sketch he had just completed, which he judged "most promising," Steele wrote:

> *The afternoon effect, the warm sunshine, the cool shadows. The sunshine having the quality that haze gives to the beams that pass through it [in] later afternoon. The gray of the distance, and the stubblefield until it culminates in the luminous tones upon the white cattle in the foreground. The color, too, becoming very pronounced until it reaches the cattle and brighter and deeper still in the sunlit grass of the foreground.*

The thirty-eight paintings reproduced here in color, many of which appear in print for the first time, represent the full range and achievement of Steele's lifelong observation of the effects of light and shadow on the landscape and reveal the artist's acute and sensitive perception of nature's "loveliness, purity and veracity."

This book and Calvin Kimbrough's artful video documentary invite a fresh study of the work of "an American master of light," a study that promises rich rewards.

John W. Streetman III
Executive Director
Evansville Museum of Arts & Science

*T*HE PRIDE EVINCED BY THE PEOPLE OF Indiana in their nineteenth-century artists and artistic traditions is apparent in the many serious publications that have appeared on the subject, dating back as far as 1916 with the publication of William Forsyth's *Art in Indiana*. While a celebration of native talent may not be unique—there are numerous studies of nineteenth-century painters and sculptors from neighboring Ohio—what is unusual is the relative lack of nationally recognized masters from Indiana, in contradistinction to the many famous artists from Ohio, or even from Missouri and Illinois, states whose artistic histories remain relatively little studied. Only one truly celebrated painter emerged in the nineteenth century from a background or early training and practice in Indiana, William Merritt Chase, and his mature career as artist and teacher was pretty much confined to the East Coast. This was not true of his near contemporary, Theodore Clement Steele, who like Chase sought training abroad in Munich, but unlike Chase returned to establish his career in his native state. And while Steele is much admired today among Indiana art lovers, his art is little known outside the state, although in his own lifetime his paintings were praised, exhibited, and acquired nationally. Steele's election as associate member of the National Academy of Design in New York City in 1913 confirmed him as the most famous Hoosier artist of his time.

Steele was born near Gosport in southern Indiana in 1847; four years later the family moved north to Waveland, where in 1859 at the age of twelve he entered Waveland Collegiate Institute. His intuitive artistic skills were so quickly honed there that the following year he was put in charge of a drawing class. After completing his studies in 1868, Steele went briefly to Chicago for further instruction where he practiced portraiture. Two years later he married a former fellow Waveland pupil, Mary Elizabeth (Libbie) Lakin, and the Steeles moved to Battle Creek, Michigan, where they stayed for three years. They soon were the parents of two children, Rembrandt (Brandt) and Margaret (Daisy), born respectively in 1870 and 1872. A third child and second son Shirley was born in 1878. In 1873 the family moved back to Indiana and settled in Indianapolis, where Steele attempted to earn a living as a portraitist. Early in 1877 he and a group of Indianapolis artists organized the short-lived Indianapolis Art Association, which in turn spawned the equally short-lived Indiana School of Art at the end of the year.

One of the school's founders and teachers was James Gookins from Terre

Haute, whose career had been established in Chicago. Gookins had studied in Munich in the early 1870s, and it may have been he who urged Steele to do likewise. In truth, however, there was a strong tradition for young midwestern artists, especially from communities with large German populations, to seek their advanced training in Munich rather than Paris, which drew most American art students. All told, about four hundred Americans studied in Munich in the nineteenth century, while easily five times that number trained in the French capital. Steele, with financial support provided by thirteen Indiana friends and patrons, traveled to Germany and, enrolled in the Munich Royal Academy. On October 16, 1880 he began his study with Gyula Benczur, a Hungarian artist of some reputation. The opportunity to study the works of the old masters in the galleries of the Pinakothek was of equal significance in Steele's formal training .

The following summer Steele and his family moved from Munich and settled in Schleissheim, six miles from the Bavarian capital. There he began painting landscapes under the guidance of J. Frank Currier, one of the most renowned American expatriates in Germany. Currier had begun his studies in Munich in 1870 and had remained there after his colleagues, Frank Duveneck, Chase, and Walter Shirlaw, had left—Duveneck to teach and work in Italy, and Chase and Shirlaw to settle in New York City. All of these artists had imbibed the more vigorous, painterly, and very unacademic manner practiced in Munich by Wilhelm Leibl and his followers, a group known as the *Leibl-Kreiss.* The *Leibl-Kreiss* were inspired more immediately by the French realist Gustave Courbet and, more distantly by the late work of the great Dutch masters Rembrandt and especially Frans Hals.

When the academy reopened in October 1880, Steele entered the painting class of Ludwig von Loefftz, a severe disciplinarian with a disdain for spontaneous effects, who remained Steele's teacher for the rest of his five-year stay in Munich. Thus Steele was exposed to two divergent sets of strategies, applicable to separate thematic concerns—sketchily painted landscapes and carefully drawn and finished figure works. The conflict inherent in such experience was not that unusual for many artists in the 1880s who were trained in both Munich and Paris. Although Steele advanced in proficiency to such a degree that his painting *The Boatman* (1884) won *p 13* a silver medal in the annual student exhibition in the summer of 1884, it was Currier's (and ultimately Leibl's) more dynamic aesthetic which ultimately became the hallmark of Steele's art.

One can trace Steele's development during one year in Munich from the charming urban scene *Winter Afternoon–Old Munich* (1883), in which the two small *p 27* figures are rather stiffly rendered, to the vast panorama of the open-ended *Haying Scene* (1884). In the later work, the tiny figures of peasants and animals are superbly *p 29* delineated, while the landscape and sky are vigorously brushed in a manner almost

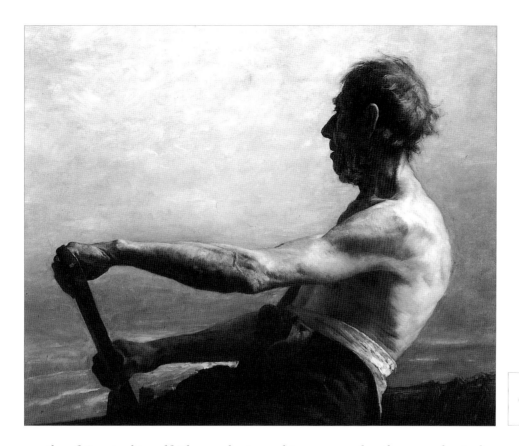

THE BOATMAN, 1884
Oil on canvas, 37 1/2 x 45 1/2 inches
Private collection

worthy of Currier himself. The emphasis on chiaroscuro rather than on color is also typical of Currier and the work of the *Leibl-Kreiss*, as is the concern for the realities of peasant life. Typical also of many of the studio works done at the academy by Steele and his fellow students is the peculiar back lighting, or *contra-jour* technique, with a number of the figures almost obliterated in blackness and picked out by thin silhouettes of light. This technique is even more truly and skillfully applied in *Village* p 31 *Scene* (1885), probably one of the last pictures Steele painted in Germany and one marked by a proficiency in figure drawing and dramatic lighting that he would never transcend. Steele's keen observation of the ruggedness of peasant life is made evident by the stony grass plots, the uneven fence, gate, and window boards, and the roughly stuccoed surface of the building at the right.

On May 23, 1885, the Steeles left Germany, departing from Antwerp, Belgium, on the *Nordland*. They docked in New York on June 6 and returned immediately to Indianapolis. There they leased Tinker Place, a home on Sixteenth Street between Pennsylvania Street and Talbot Avenue near the northern edge of the city, where they would remain for much of their Indianapolis residence. The following year Steele added a studio to the property. The city was already familiar with his Munich painting, since he had sent pictures back during his student days, and two

months before his return a show of pictures by Steele and fellow Hoosier, William Forsyth, with whom he had studied art in Munich, had been held at English Hall in Indianapolis.

In Indianapolis Steele returned to portraiture, both to fulfill his obligations to the patrons who had supported him abroad and to ensure a livelihood. Painting commissioned portraits did not entail the financial hazards of speculative landscape and still-life work, and Steele painted many of them, especially during the winter and early springtime, before venturing out-of-doors to engage in landscape work. With his Munich training in figure drawing and painting behind him, Steele was an assured portraitist, if not always an especially inspired one; it was he who was chosen to paint the likenesses of five successive Indiana governors. Like many an artist, his more personal likenesses were also his finest and most expressive, such as *Portrait of Daisy* (1891). Still emphasizing the neutral tones favored by the artists who had *p 42* trained him in Munich, Steele painted a somber, almost haunting likeness of his daughter, devoid of the sentimentality which one might expect in a familial image. Perhaps it is not too much to see in the moving, slightly melancholic interpretation of the portrait a reflection of Dutch Baroque art, especially the painting of Rembrandt, that Steele's teacher Loefftz so admired.

After his return to Indiana, Steele was to devote himself primarily to scenic art. It is now a truism that he and the painters who were shortly to be designated as the Hoosier Group returned from Europe to Indiana, where they remained to explore the beauties of its placid landscape, peaceful rivers, and small communities, unlike the majority of midwestern painters who studied abroad and settled in New York City or elsewhere in the East.

For quite a while, Indianapolis itself remained Steele's base of operation as it did for several of his colleagues, and the city itself is not absent from his pictorial repertory. *Pleasant Run* (1885), although a rural scene, actually depicts a site within the city limits. To this scene Steele brought the dark drama and back lighting characteristic of many of his Munich paintings, while also incorporating greater color contrasts and a thicker and more luminous haze than in the landscapes painted abroad. He later repeated the composition of *Pleasant Run* (1887) on a slightly smaller *p 33* scale—a true replication, since even several of the cows by the bridge over the run are identically placed.

Throughout his career the urban scene was attractive to him as a subject, including his own home *Tinker Place*, which he painted in the winter of 1891. Here *p 44* Steele renders the confluence of the rural and the urban—a theme which also interested many of the French Impressionists—but in very midwestern terms. *Street Scene With Carriage* (c. 1894) is a fully urban view that emphasizes the filmy, blue- *p 51* gray atmosphere of a rainy day. Painted in what would be termed a tonal manner,

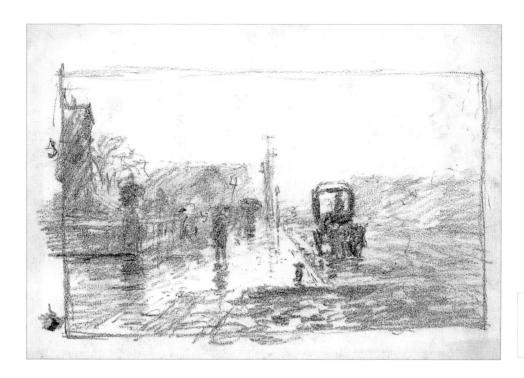

Steele's cityscape is comparable to some of the city views created by Childe Hassam in New York at much the same time, or the tonalist city scenes that would be produced there by Birge Harrison in the following decade. Many painters of the period explored the effects of weather conditions in the city, certainly in part because inclement days were less conducive to outdoor landscape painting, but also because snow and rain modified the stark and megalopolitan nature of the modern city. Steele was no exception, and in 1918 toward the end of his life, he painted a number of city scenes such as *Monument in the Snow*. Here the small figures trudging up and down the steps of Bruno Schmitz's great Soldiers' and Sailors' Monument (1902), on the Circle in central Indianapolis, are dwarfed by the snow-covered sculptures. *p 73*

In addition to Steele's urban paintings, his non-portrait work consisted of rural scenes painted outside of the state's capital. Some of the earliest of these still continued to reflect the character of his Munich work, such as the appropriately titled *A June Idyll* (1887), which features twelve-year-old Daisy reading to her younger brother Shirley under a grove of trees in a rocky landscape. The sharply defined figural work, dark shadows, and rather scraggly foliage reflect his Germanic artistic heritage. Likewise, the surface roughness, the irregularly shaped, somewhat bare foliage, and the melancholy atmosphere that suffuses *A Bleak Day* (1888) all suggest the unidealized, barren landscapes often preferred by Munich artists such as Currier and his followers in the 70s and 80s. Daisy appears again, reading in a more *p 34-35* *p 36*

orderly but still rocky setting, in *Daisy by the River* (1891), where patches of bright *p 43* sunlight suggest Steele's changing aesthetic concerns.

A June Idyll may have been painted in a rural spot not far from the Steeles' *p 34-35* Indianapolis home, but tradition has it that it was done in Ludlow, Vermont, where he spent four months that summer and autumn. There and in nearby Cavendish, Steele painted commissioned portraits and investigated the landscape of the Green Mountains. Certainly the rocky terrain against which the figures are silhouetted seems inspired by a northern New England setting.

Steele's outdoor summer work in other years usually took him, sometimes with his family, sometimes on his own, to various rural areas throughout the state. Because of the general pastoral nature of these landscapes, the exact sites depicted are often difficult to identify. *The Shades* (1888) is an example. It is documented that *p 37* it was painted near Yountsville along the bank of Sugar Creek in Montgomery County, a few miles from Steele's boyhood home at Waveland. The family had spent the summer on a newly-developed camp ground at Sugar Creek, advertised for its refreshing scenery and natural spring waters. The dark, silhouetted trees at the right recall the earlier Schleissheim landscapes, while the infusion of richer colorism in the rest of the scene and the casual bucolic spirit mark this painting as the beginning of Steele's unique pictorial reaction to his native environment. Two summers later, he was painting with his friend, colleague, and fellow Munich student, John Ottis Adams, along the Mississinewa River in Delaware County, where *In the Berry Field* *p 40* (1890) may have been painted. The theme of field workers immediately calls to mind Steele's earlier scenes of rural labor painted in Germany, such as *Haying Scene* *p 29* (1884), but the more casual arrangement of the figures and the inclusion of well-dressed women alleviate the sense of hard toil. This scene instead prompts comparison with the nearly contemporary, paradigmatic picture of American communal work by Eastman Johnson, *Cranberry Harvest, Island of Nantucket* (1880).

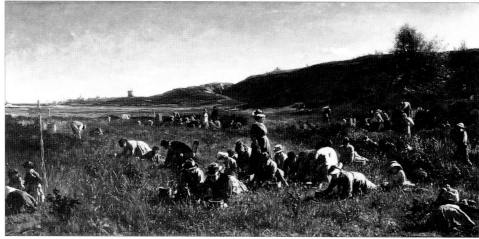

EASTMAN JOHNSON
*CRANBERRY HARVEST, ISLAND OF
NANTUCKET, 1880*
Oil on canvas, 27 1/2 x 54 5/8 inches
The Putnam Foundation
The Timken Museum of Art, San Diego, California

From 1890 to 1895, Steele worked during the summers in and around the old Indiana town of Vernon on the Muscatatuck River, where he had previously painted as early as 1886. The first three summers he worked with another of his Munich colleagues, William Forsyth, one of the most innovative of the Munich-trained Hoosiers. Although Forsyth adopted an impressionist mode, he painted at times in a less naturalistic, more expressionist manner than did Steele, utilizing strategies that ultimately could be traced to his training with Currier. Steele, Forsyth, and Adams remained the core of the Hoosier Group and close colleagues and friends throughout their lifetimes. Forsyth also joined Steele in Indianapolis in 1891 to teach at the Indiana School of Art.

p 146-47 During this time, Steele painted the monumental *Summer Days at Vernon* (1892) in which the unique Munich sensibility of back-lit landscape forms and scraggly but formally balanced silhouettes harmonize with the brilliant sunlight and pastoral beauty that mark Steele's vision of rural life. A few years later Steele would abandon entirely the darker drama of Munich, replacing it with lighter, sometimes even p 49 pastel tones, and casual, asymmetrical compositions. *Morning by the Stream* (1893) p 45 and *November's Harmony* (1893) exemplify these stylistic modifications, as does Steele's most renowned picture of that year *The Bloom of the Grape* (1893), which was exhibited in the Paris International Exposition of 1900.

The paintings of 1893 reflect Steele's conscious philosophy of modern landscape painting, a philosophy he set forth in a lecture entitled "The Trend of Modern

Art (The Gospel of Beauty)," delivered to the Convention of Indiana Union Literary Clubs in Huntington in May 1895:

> *The painter of today is more sensitive to the quality of light. He now regards light as the great fact in nature. It is light that gives mystery to shadow, vibration to atmosphere, and makes all the color notes sing together in harmony. . . . There is another characteristic of modern landscape that is worthy of notice. It is the growth of an appreciation of the quieter elements and qualities of landscape beauty. The Niagaras and Yosemite valley have had their day, and now the painter finds suffi-cient interest in the hillside pasture and the meadow brooks, in a country road, and in fact it seems that in his choice of subject most anything will do.*

It is surely not coincidental that at this time, when Steele was completely resolving his personal philosophy of landscape painting, critical esteem for his work was also increasing beyond the purely local. Indeed the artist was being hailed as one of the standard-bearers of a uniquely American form of Modernism, one arising appropriately from the nation's heartland. Steele had already gained some national notoriety when he began showing a number of his German pictures with the Society of American Artists in New York in 1886, and especially when *On the Muscatatuck* (1886) was purchased by the Boston Art Club after it was exhibited in the club's annual exhibition in January 1887. In 1893 Steele and Forsyth were the only Indiana artists whose works were included in the art exhibition at the Columbian Expo-sition in Chicago. Steele exhibited a later version of *On the Muscatatuck* (1892) and *September* (1892), both painted in Vernon. The jury ranked one of Steele's canvases

SEPTEMBER, 1892
Oil on canvas, 30 1/8 x 45 1/4 inches
Private collection

as a "one" out of three levels of achievement, and Steele was the only western artist to be so honored.

At the exposition, Steele was exposed to the work of the French Impressionists, perhaps for the first time. The influence of Impressionism can be seen in the higher colorism manifest in the pictures of 1893 painted after the exposition, such as *Morning by the Stream* and *November's Harmony*, as well as in the rich, warm sunlight of *Berry Picker* (1894), which was probably painted in Vernon during his last season there. It should be noted that a number of American impressionist pictures by artists such as Childe Hassam, William Merritt Chase, and John Twachtman had been exhibited at the Art Association of Indianapolis as early as 1890, three years before the Columbian Exposition.

p 52-53

The appearance of works by Steele and Forsyth in the Columbian Exposition led the noted writer and critic Hamlin Garland to invite Steele, Forsyth, Otto Stark, and Richard Gruelle to show their work at the Chicago studio of the city's leading sculptor, Laredo Taft, Garland's brother-in-law. The four artists had previously shown their work in November of 1894 at the "Exhibit of Summer Work by T. C. Steele, William Forsyth, R. B. Gruelle, and Otto Stark," sponsored by the Art Association of Indianapolis at the Denison Hotel. The Chicago show was sponsored by the Central Art Association, an organization promoting western art, of which Garland and Taft were among the prime movers. This exhibit included the same paintings shown in Indianapolis, and added two paintings by John Ottis Adams, whose work was unaccountably missing from the earlier show. Garland entitled the exhibition — and thus christened the five painters— "The Hoosier Group" and championed the group as a model for a distinctly American Modernism based on their adaptation of contemporary, i.e., impressionist principles. The exhibition, as discussed in the association's publication *Five Hoosier Painters*, was admired for being "conservatively impressionistic," with Steele regarded as "the biggest man of the lot." Local, regional, and national critics echoed Garland's endorsement of the Hoosiers. The prestigious New York magazine, *The Art Amateur*, noted in March 1895:

> *Among the Indianapolis painters whose work is making some stir in the West, T. C. Steele is pre-eminent for broad handling, poetic spirit and agreeable color. He is of the impressionist school, and deals in the glorification of the commonplace Indiana landscape.*

p 54, p 58

This "glorification" can be seen in *Cows by the Stream* (1895) and *Mysterious River* (1895) where the beauty of the mundane is achieved by the skillful handling of color intensity and a sensitivity to light, atmosphere, and changing weather conditions. The question of the degree of Steele's commitment to the then-modern impressionist aesthetic, and exactly when he might be grouped among the artists of that school as

Garland had labeled him in 1894, has arisen frequently but may be irrelevant. Certainly after 1893 and the Columbian Exposition, Steele increasingly adopted the strategies of the impressionist movement, and by the early years of the twentieth century, he was producing pictures that seem to suggest total commitment. But he is not to be so easily pigeon-holed as later art historians might wish. On the other hand, he was truly attracted by modern aesthetics from the time of the Columbian Exposition. This is established by his essay on "Impressionalism," published in the spring of 1893 in the nation's foremost contemporary art magazine, *Modern Art*, a periodical which had just then been established in Indianapolis. Steele also wrote an unpublished essay, probably delivered as a lecture soon after the exposition, in which he recognized Monet as the leader of the impressionist movement and expressed admiration for his work. Steele certainly approved of the impressionist technique of placing colors side by side upon the canvas, unmixed, based upon the study of light. But his subscription to the movement was tentative, and he called for greater structural qualities and imagination in design, and a greater spiritual and poetic significance. It was certainly these constituents which he strived to incorporate into his own impressionist canvases.

Steele resigned from the Indiana School of Art in 1895 and spent the summer in Spencer, where his wife, increasingly ill with rheumatoid arthritis, was placed in a sanitarium. He then joined John Ottis Adams at Black's Mill on the Mississinewa, exploring the flat, prairie-like landscape where his 1895 pictures were painted. In October 1896, Steele joined Adams in Metamora on the Whitewater River, a new area for pictorial exploration and one which would be vital to the development of Hoosier landscape painting. *Street Scene* (1896), a rare rural townscape, may depict *p 57* Metamora or a nearby community. The following year Steele and Adams returned to Metamora, and a sketching trip down the Whitewater to Brookville led them to purchase The Hermitage in 1898, which remained their painting base until Steele sold his half-interest in the house to Adams in 1907.

Steele's fame as the premier Hoosier painter continued to increase. In 1896 he was appointed vice-president of the Art Association of Indianapolis. At the same time, he, Forsyth, and Adams headed the Indiana contingent of the Society of Western Artists, which organized traveling exhibitions of the work of midwestern painters for a period of almost twenty years. In 1898 Steele became president of the society. Meanwhile, the health of his wife Libbie became increasingly precarious when she contracted tuberculosis, and the family summered that year in Roan Mountain, Tennessee, in the hopes of alleviating her condition. Although Steele's increasing concern for his wife's health led to some landscape painting that reflected his anguish, *Tennessee Scene* (1899) is one of his most sunny and placid works. Perhaps immers- *p 55* ing himself in the beauties of nature was an attempt to relieve his despondency.

Libbie died in November 1894; their younger son Shirley married the following year and moved to California; and in 1901, when the lease terminated, Tinker Place was sold to the Art Association of Indianapolis which opened the John Herron Art Institute there. Steele and his two unmarried children, Brandt and Daisy, moved to a small house on East St. Clair Street, while the artist continued to summer at The Hermitage in Brookville. There he painted rural scenes of great beauty such as *Along a Country Lane* (1901) and *The Grist Mill* (1901).

p 64, p 56

After Brandt's marriage in June 1902, Steele and his daughter journeyed west the following month to visit family in Oregon and California. They traveled to Chicago and St. Paul, through the Dakotas to Moose Jaw in Saskatchewan, Canada, and then on through the Rockies to Vancouver on the Canadian Pacific Railroad. From there they traveled south to Albany in the Willamette Valley in Oregon, passing through Seattle, Tacoma, and Portland. Once Steele reached the Oregon shore, he began to produce a series of vigorously painted coastal scenes with an enhanced colorism that is evident in *Clam Diggers* (1902), painted near the twin resorts of Newport and Nye Creek Beach. This was a new experience for Steele, who quickly mastered the artistic conventions of the seascape. During the month he and Daisy spent at the Oregon shore among hundreds of vacationers, Steele completed fifteen canvases. Steele and his daughter continued south to San Francisco and then to Redlands in Southern California, where Shirley and his wife were living. They returned home in November by way of Arizona, New Mexico, Colorado, and Kansas.

p 66-67

Steele returned to the Far West the following year, visiting many of the same locales he had the previous year, producing works such as *Puget Sound* (1903) and *Oregon Coast* (1903). Steele appears to have been about the earliest professional artist to have been inspired by the central Oregon coastline. Painters native to the state, it appears, did not begin to explore the landscape to any extent until a decade later. Although Steele was very proud of the results of his pictorial excursions into such unfamiliar territory, in a paper he delivered to the Portfolio Club in Indianapolis in 1903, he promised

p 63

p 68-69

> as a lover of my State and a believer in the beauty of its scenery, that I will love none the less but perhaps appreciate the more its charms of woodland hill and field because I have lived awhile where the long waves of the Pacific break on the Oregon coast

For the rest of his career, Steele devoted his art primarily to depicting the charm of Indiana's woodland hills, streams, and fields. Before moving to Brown county in 1907, he divided his time between an Indianapolis studio in the Hartford Block during the winter and The Hermitage in Brookville during the summer. *Whitewater River* (1904) is a rather dramatic and somewhat desolate scene, without

p 62

signs of human activity or habitation. Although painted in the same year, *Flower Garden at Brookville* (1901) conveys a very different mood. It not only captures the *p 61* casual lifestyle Steele led there but also succinctly describes the natural setting of rural, eastern Indiana: the small town nestled among the gentle rolling hills, broadly and colorfully illuminated by bright sunlight. This painting reflects Steele's full commitment to the aesthetics of Impressionism, a commitment also clearly apparent in the five works exhibited in the 1904 Louisiana Purchase Exposition in St. Louis, where he served on the jury of selection and awards for the Western Division of the art gallery. *Along the Creek (Zionsville)* (1905) portrays the still-rural character *p 65* of the landscape immediately beyond Indianapolis proper, although its more concentrated forms and less expansive panorama contrast with the broader vision of his Brookville scenes.

In 1905 Daisy married Gustave Neubacher of Indianapolis, and two years later, in August 1907, Steele married Gustave's sister Selma, an artist and art supervisor twenty-three years his junior. Earlier in 1907 Steele had purchased over two hundred acres of woodland in Brown County, sixty miles south of Indianapolis. There he built a hilltop studio and home, appropriately called The House of the Singing Winds, where he and Selma settled. The Brown County residence became Steele's base of artistic activity, although winters were still spent in Indianapolis. In 1914 he was one of a large number of Indiana artists who painted a mural for Indianapolis City Hospital. The Steeles continually enlarged and modernized their Brown County home, and in 1916 the artist built a large separate studio on the grounds.

Although not far from Indiana University in Bloomington, much of Brown County remained relatively isolated and primitive. With perhaps the most rugged and varied scenery in Indiana, the county had recently begun to attract artists from the Chicago area for summer landscape work. From the time of Steele's appearance there, it became one of the most popular art colonies in the Midwest, attracting not only painters from Indiana, but others from as far as Salt Lake City and Buffalo, many of whom became either annual visitors or permanent residents in and around Nashville, the county seat.

The great majority of Steele's later paintings depicts the countryside surrounding his estate. In many of these Steele uses even more vivid light and color than he had in previous work, often concentrating on the trees, singly and in groves, that punctuate and fill the landscape—the "living denizens" of his private world. Both *The Poplars* (1915) and *Last Hour of the Day* (1916) attain a grandeur and monumentality *p 70, p 71* not only because of their size, but because of the balance and symmetry of the tall trees stretched across the middle distance—the former in bright sunlight, the latter glowing in evening light. *The Poplars* was very likely one of three paintings exhibited at the Panama-Pacific International Exposition in San Francisco, where Steele also

served on the jury of selection for midwestern art.

At The House of the Singing Winds, Selma Steele developed a commercial vegetable and fruit garden and supervised a flower garden which added new dimensions to her husband's paintings. Steele had never ignored floral subject matter. As early *p 38-39* as 1890 he had painted a spectacular rendering of Indianapolis's *Flower Mart,* depicting a flower show of the kind sponsored in many major cities at the time by horticultural societies. He had painted flowers in earlier landscapes such as *Flower Garden at* *p 61* *Brookville* (1901), but now flowers became a major focus of many of his finest paintings. *p 74-75* In *Child with Flowers* (1918), a profusion of flowers bloom in the garden, around the house, and on trellises on the porch, echoing a thematic interest previously more associated with his former Munich colleagues, Forsyth and especially Adams. Steele also painted a considerable number of more formal floral still lifes, table-top group-*p 75* ings of flowers in vases and other containers, such as *June Glory* (1920). He became one of Indiana's finest masters of this theme, one that he could undertake in inclement weather, and one that as he grew older required less strenuous physical effort than outdoor landscape work.

As time went on he spent more and more time at his country home. In 1922 Steele was invited to join the faculty of Indiana University in nearby Bloomington as an honorary professor of art, serving as artist-in-residence with a studio and room in the university library, and thus gave up his winters in Indianapolis. During that *p 72* first winter in Brown County, he painted *House of the Singing Winds* (1922), a snow-scape in which the house nestles securely in the Brown County landscape, with Steele's favored tall trees ranging up beyond the porch and a distant view of the valley below at the left.

Steele suffered a heart attack in December 1925, and although he recovered, his condition gradually deteriorated throughout 1926. He died on July 24 of that year in the The House of the Singing Winds. He was immediately honored by a memorial exhibition at the John Herron Art Institute in Indianapolis, which had exhibited his Brown County paintings in one-artist shows in 1910 and again in December 1920. To the end, Steele remained steadfast in his devotion to his native landscape, and his work continues to represent a late nineteenth-century vision of a uniquely American Modernism.

THE PAINTINGS

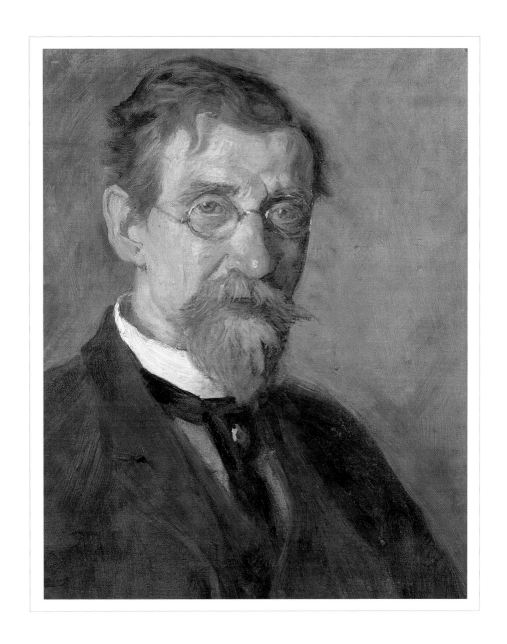

Portrait of T. C. Steele, 1913
by Frank Thompkins
Oil on canvas, 26 x 22 inches
National Academy of Design, New York, New York

WINTER AFTERNOON—OLD MUNICH, 1883
Oil on canvas, 16 1/2 x 23 inches
Collection of Eckert Fine Art, Indianapolis, Indiana

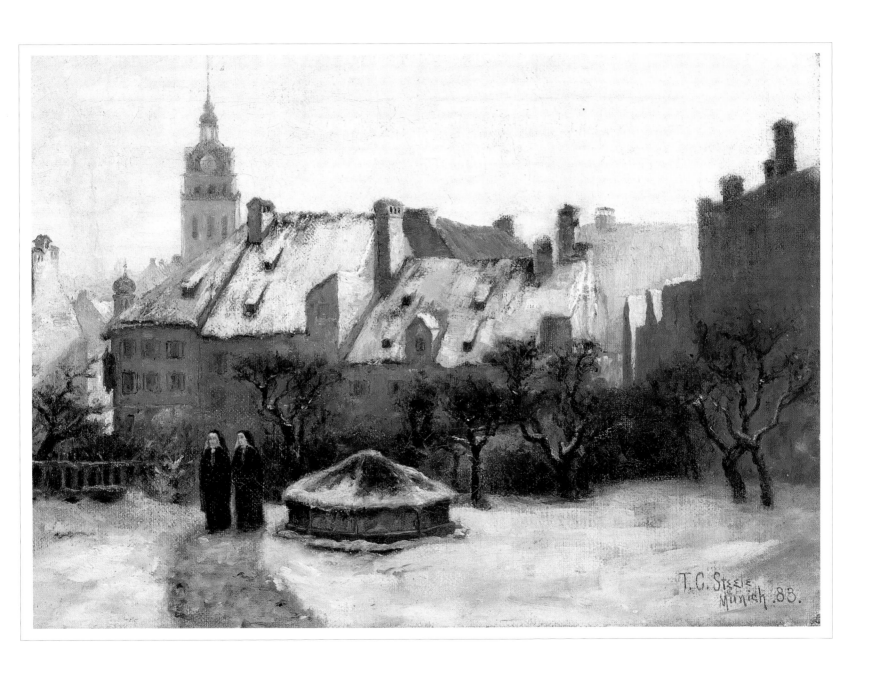

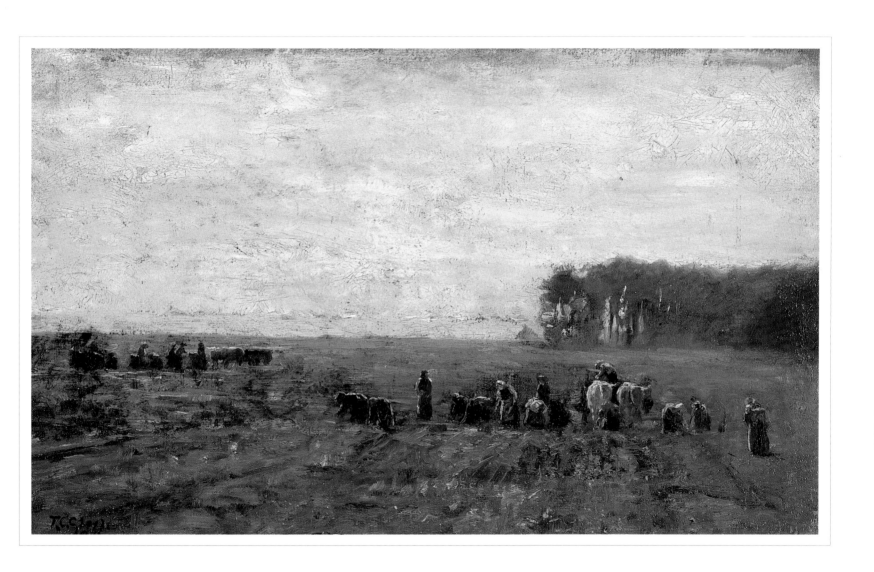

29

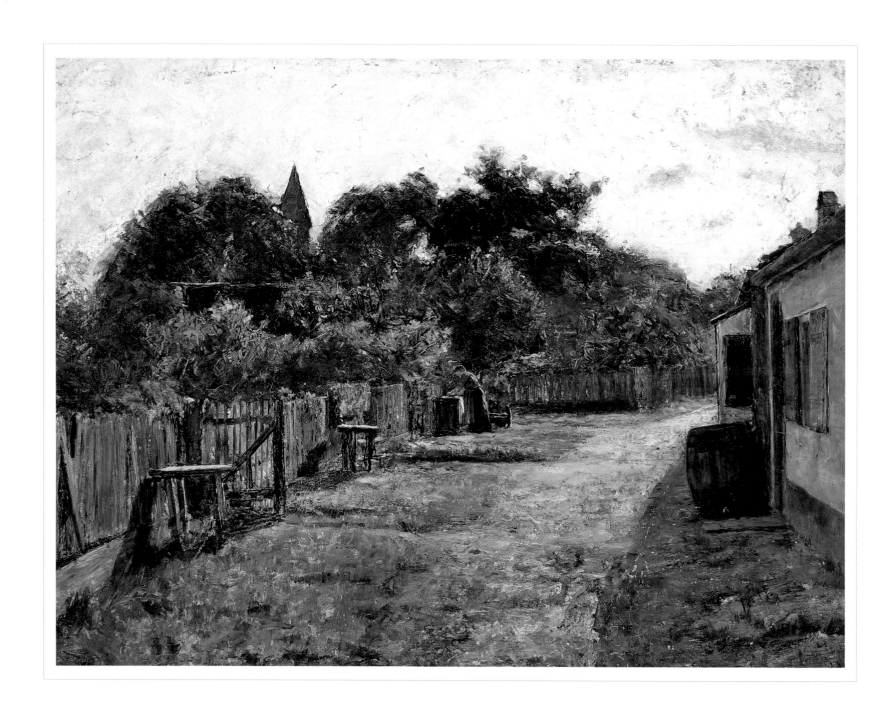

VILLAGE SCENE, C. 1885
Oil on board, 23 x 30 inches
Collection of Eugene L. and Mary L. Henderson

VILLAGE SCENE, 1885
Oil on canvas, 22 x 32 inches
Collection of Bob and Ellie Haan

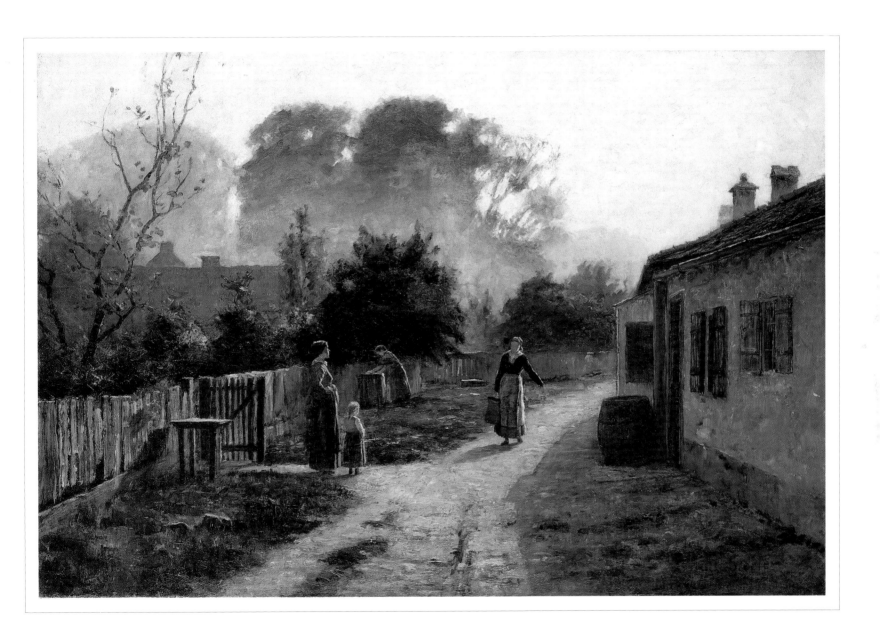

PLEASANT RUN, 1887
Oil on canvas, 18 x 26 inches
Private collection

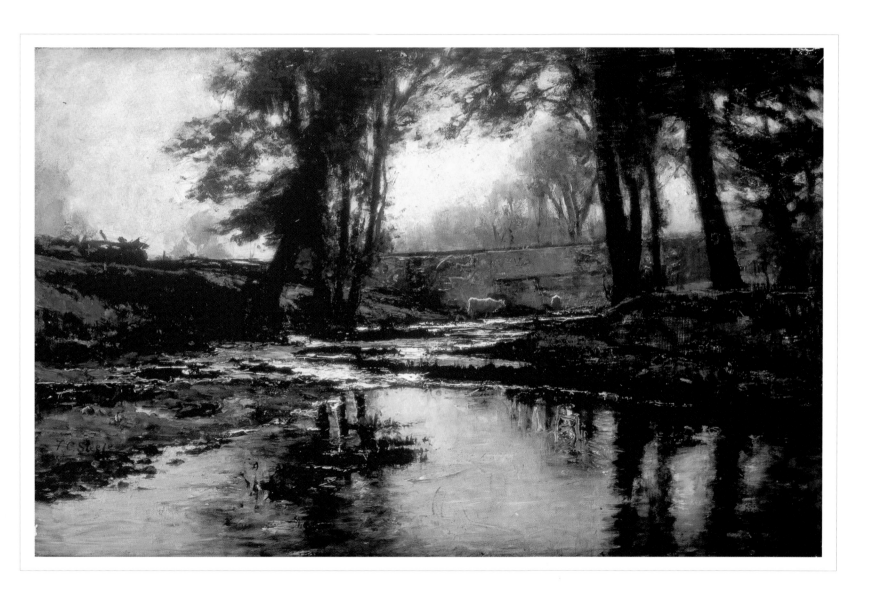

A June Idyll, 1887
Oil on canvas, 18 x 29 inches
Collection of the Indianapolis Museum of Art
Indianapolis, Indiana
Gift of Mrs. William B. Wheelock

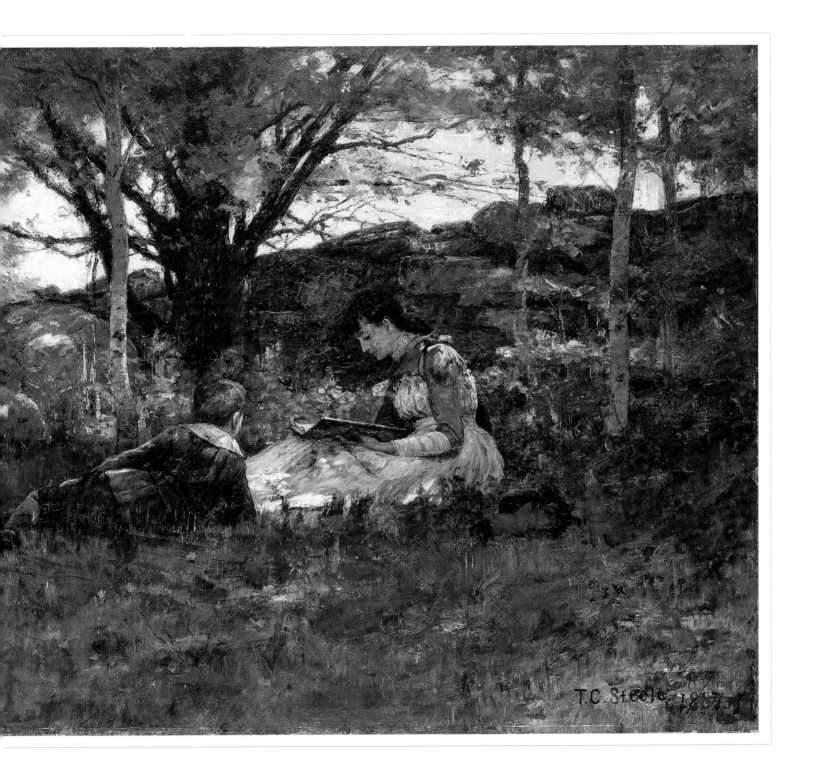

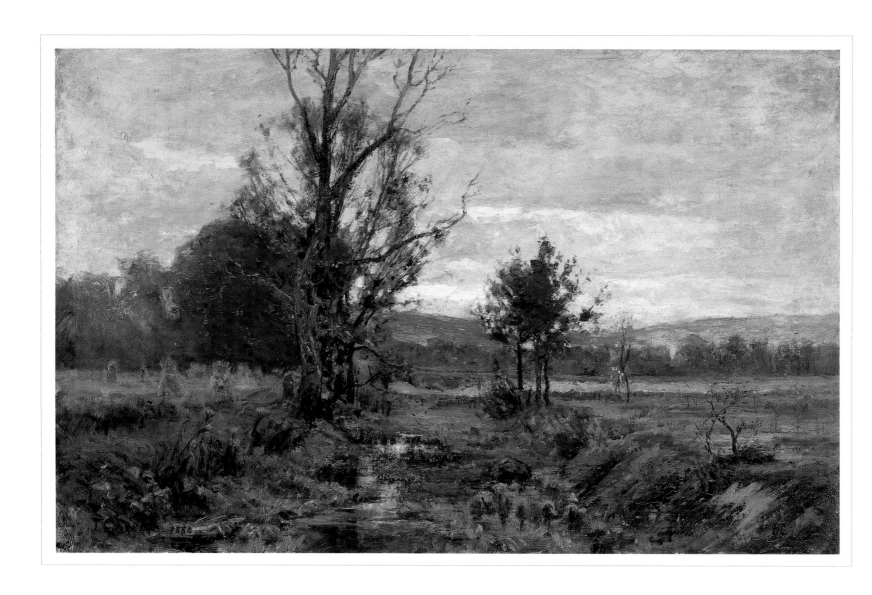

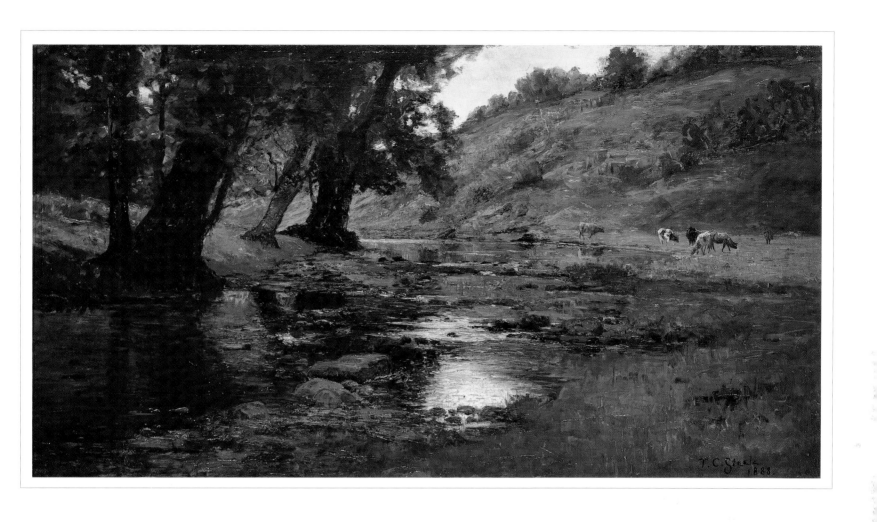

The Shades, 1888
Oil on canvas, 22 x 40 inches
Collection of Bob and Ellie Haan

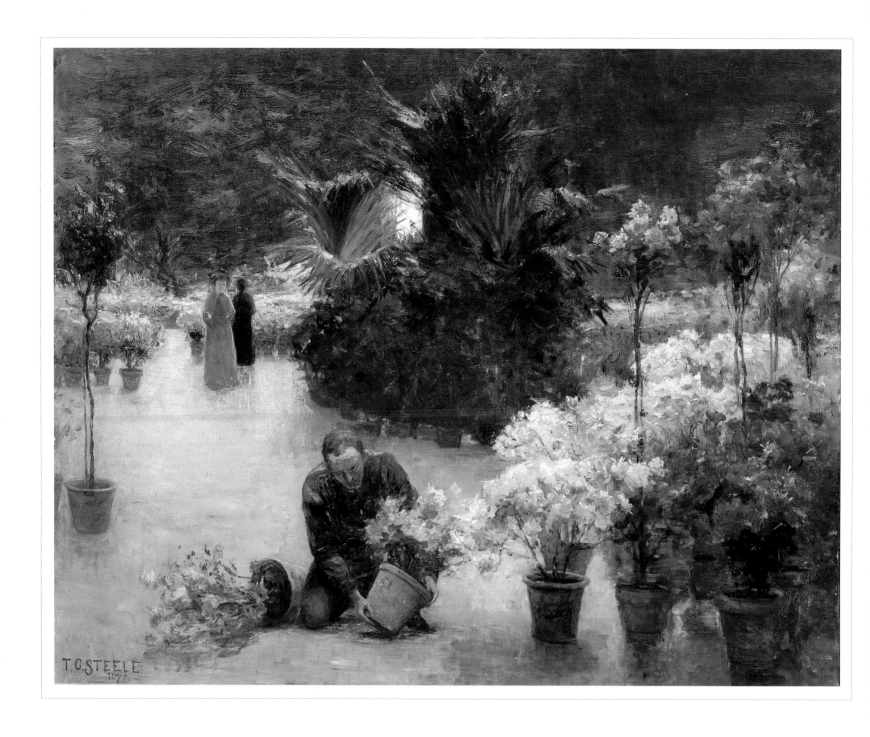

FLOWER MART, 1890
Oil on canvas, 25 x 31 1/2 inches
Private collection

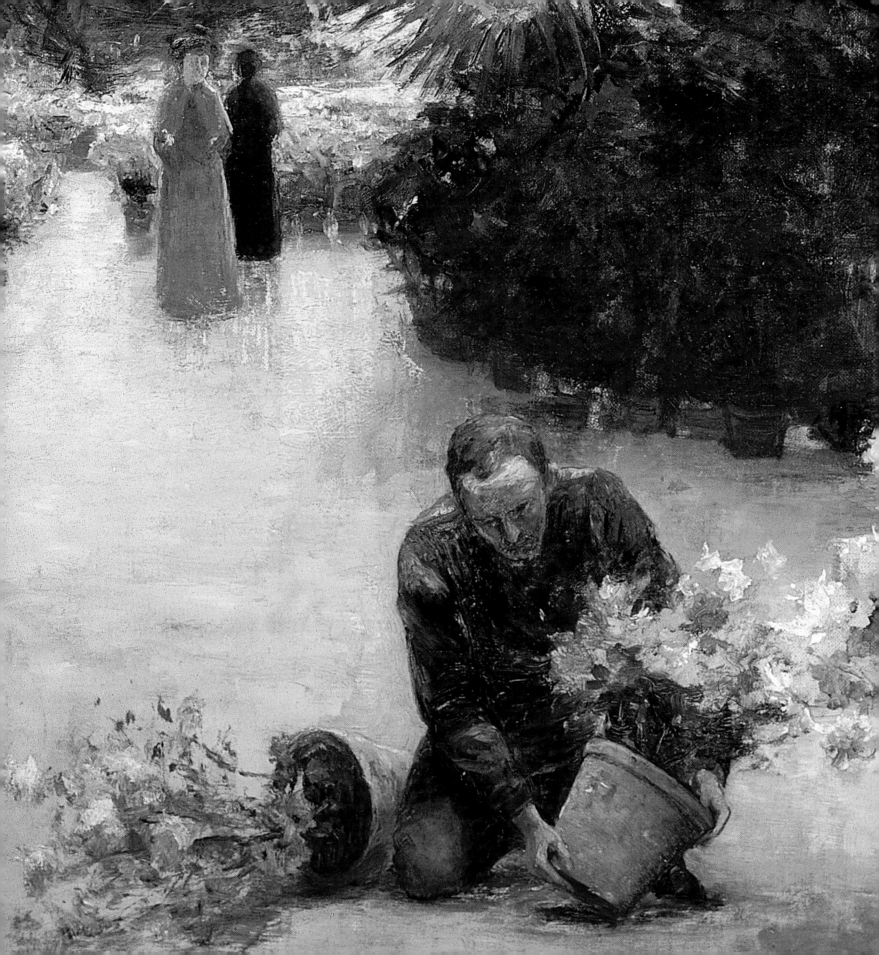

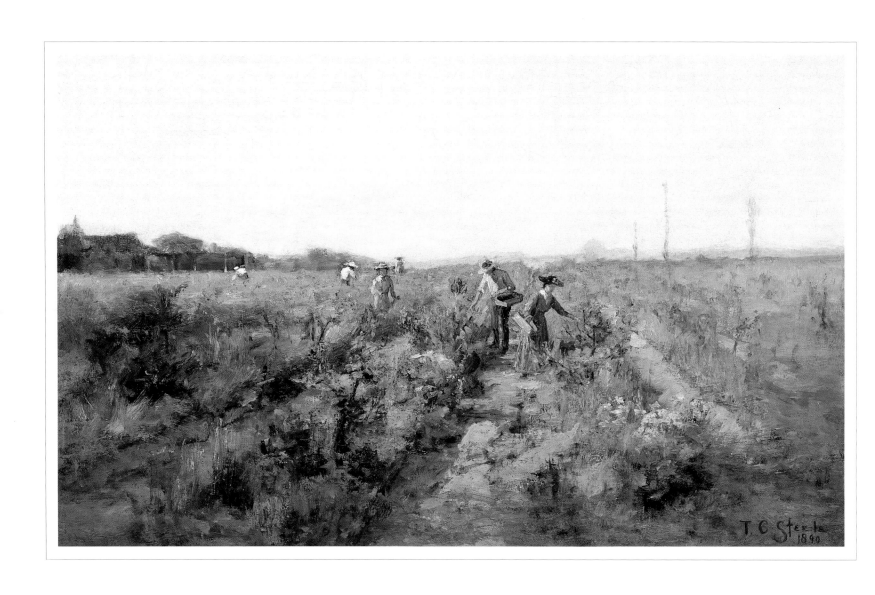

In The Berry Field, 1890
Oil on canvas, 17 1/2 x 28 inches
Private collection

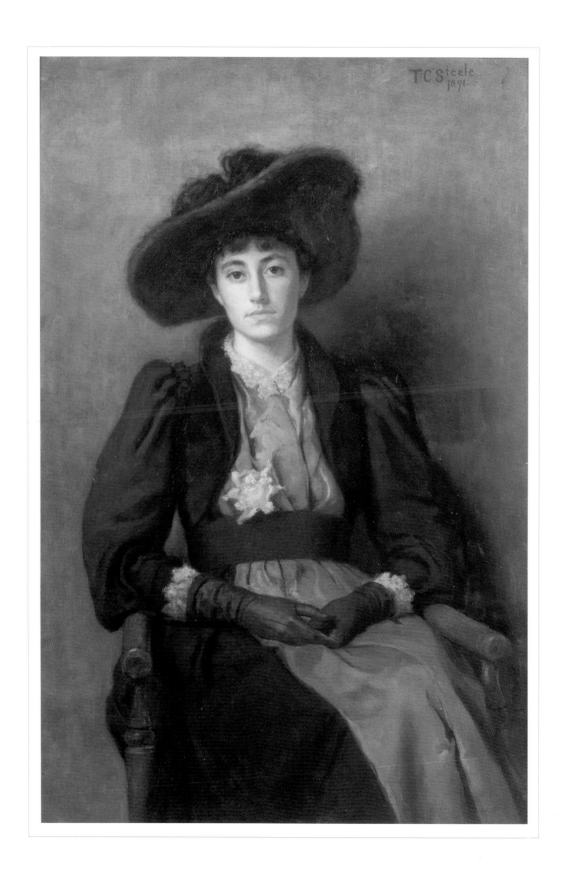

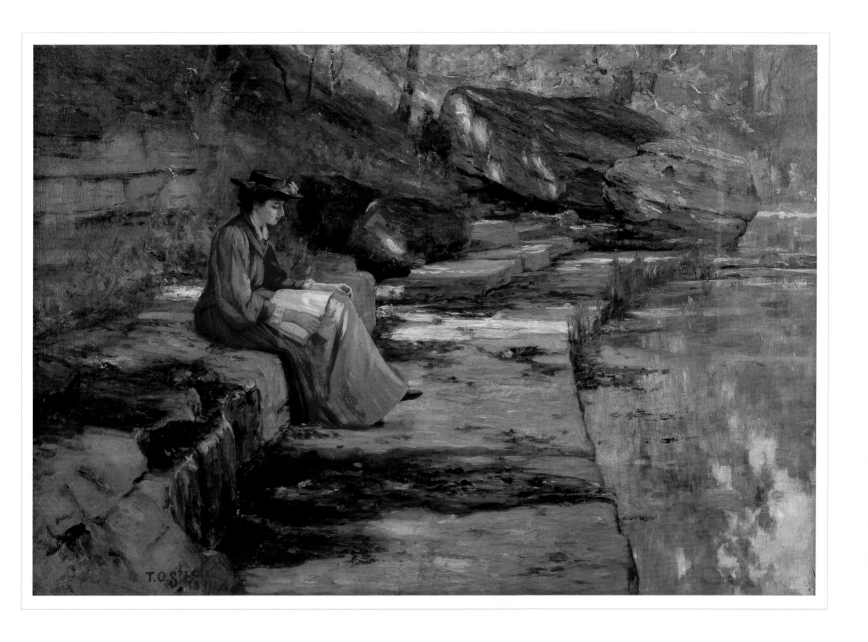

PORTRAIT OF DAISY, 1891
Oil on canvas, 45 x 30 inches
Collection of the Evansville Museum of Arts & Science
Evansville, Indiana
Gift of Mr. and Mrs. Robert B. Neubacher

DAISY BY THE RIVER, 1891
Oil on canvas, 30 x 40 inches
Collection of Jane Deuber Villacres
Great, great granddaughter of T. C. Steele

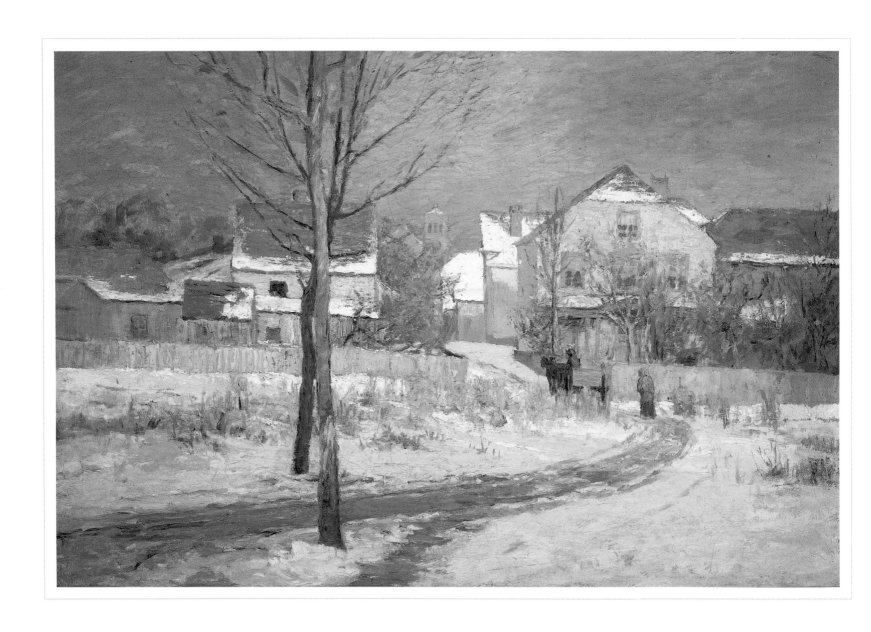

Tinker Place, 1891
Oil on canvas, 22 x 32 inches
Collection of Dr. Brandt F. Steele

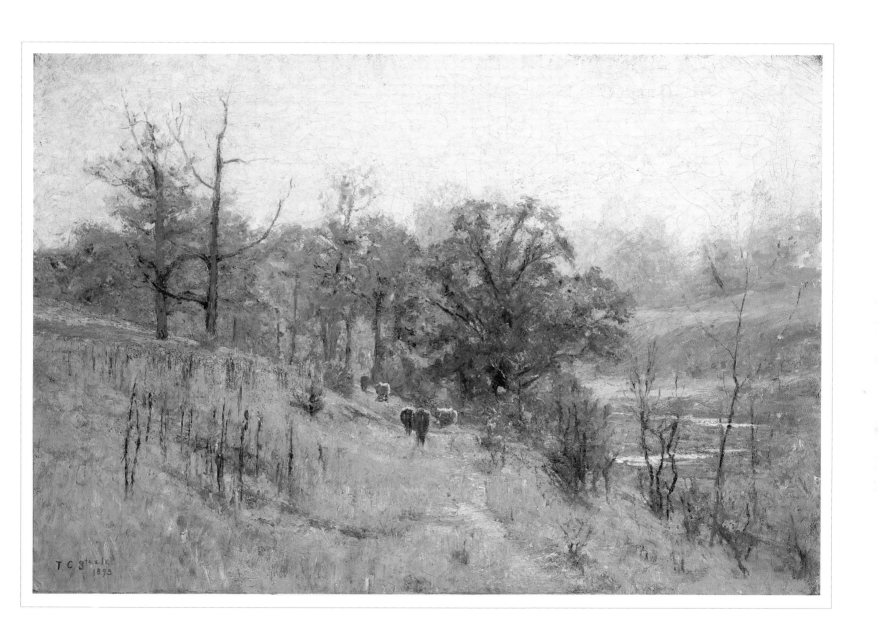

November's Harmony, 1893
Oil on canvas, 26 1/2 x 38 inches
Private collection

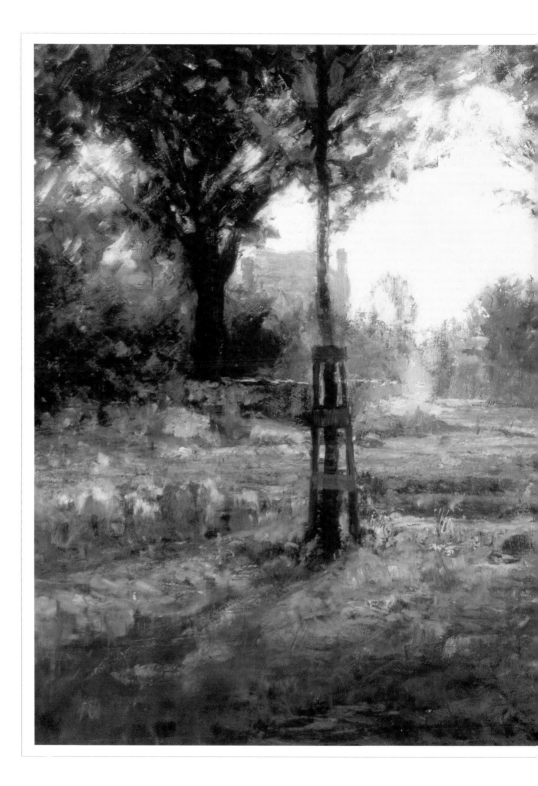

SUMMER DAYS AT VERNON, 1892
Oil on canvas, 21 x 39 inches
Private collection

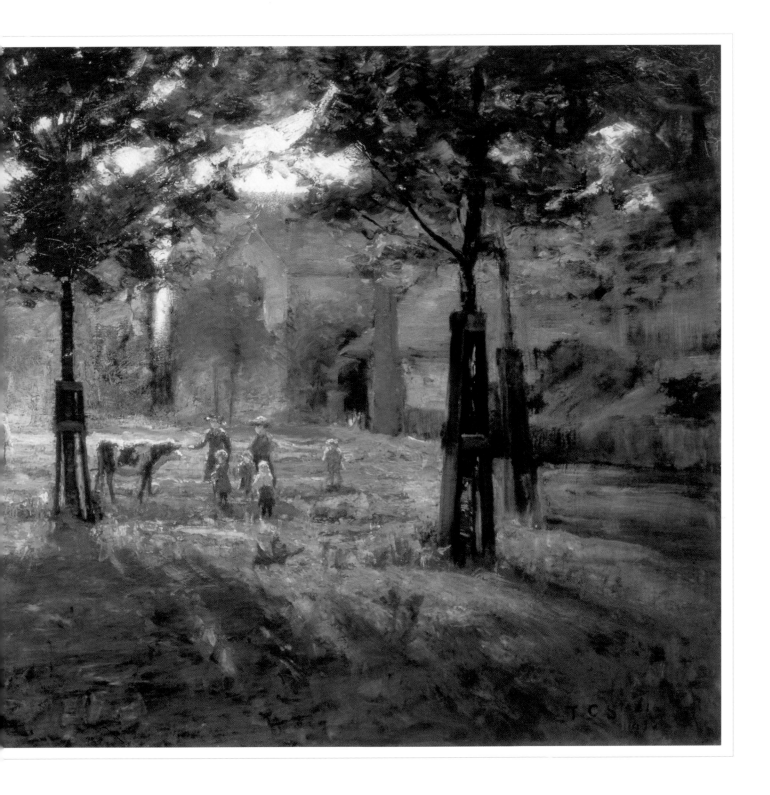

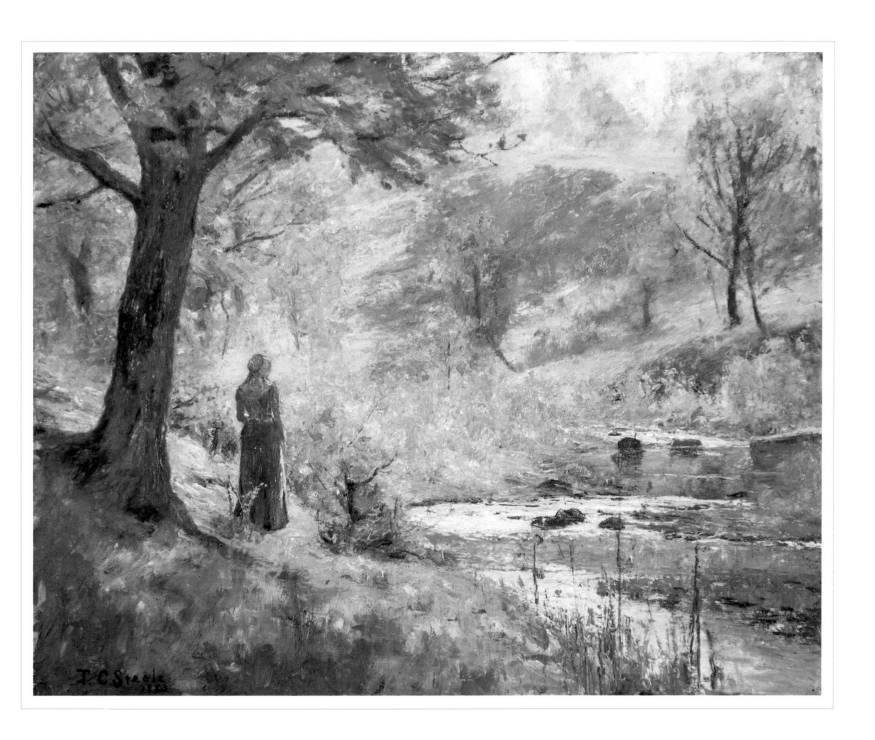

49

STREET SCENE WITH CARRIAGE, c.1894
Oil on canvas, 11 1/2 x 20 inches
Private collection

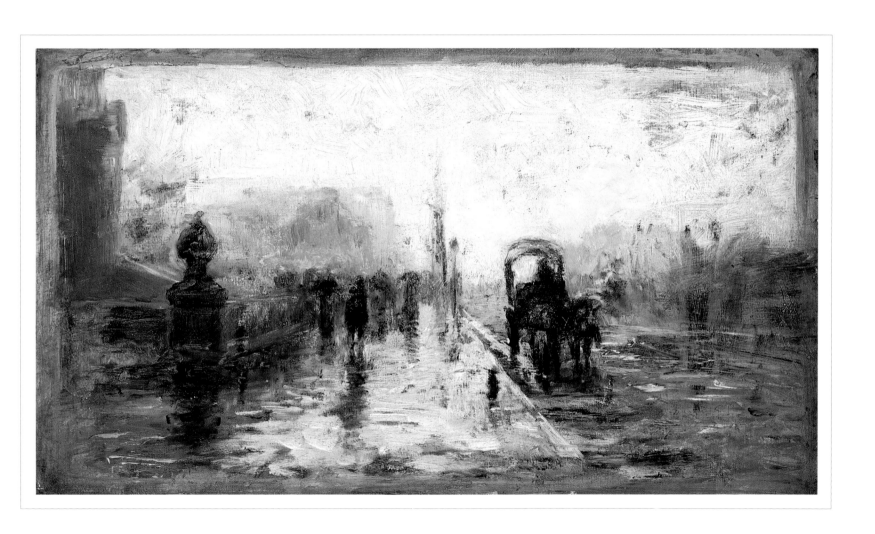

BERRY PICKER, 1894
Oil on canvas, 19 x 31 inches
Private collection

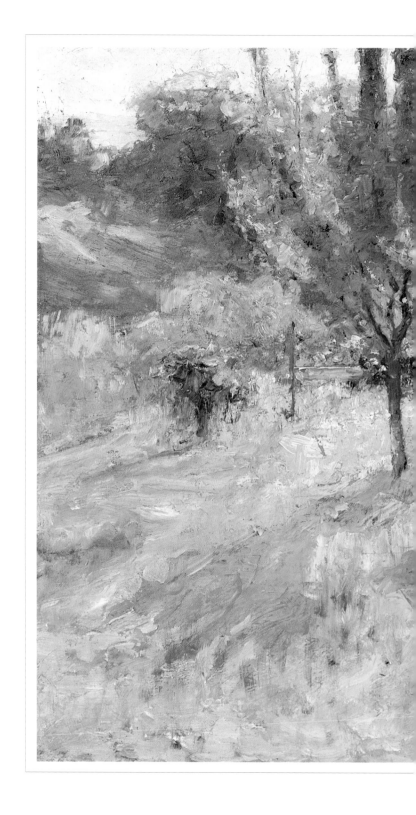

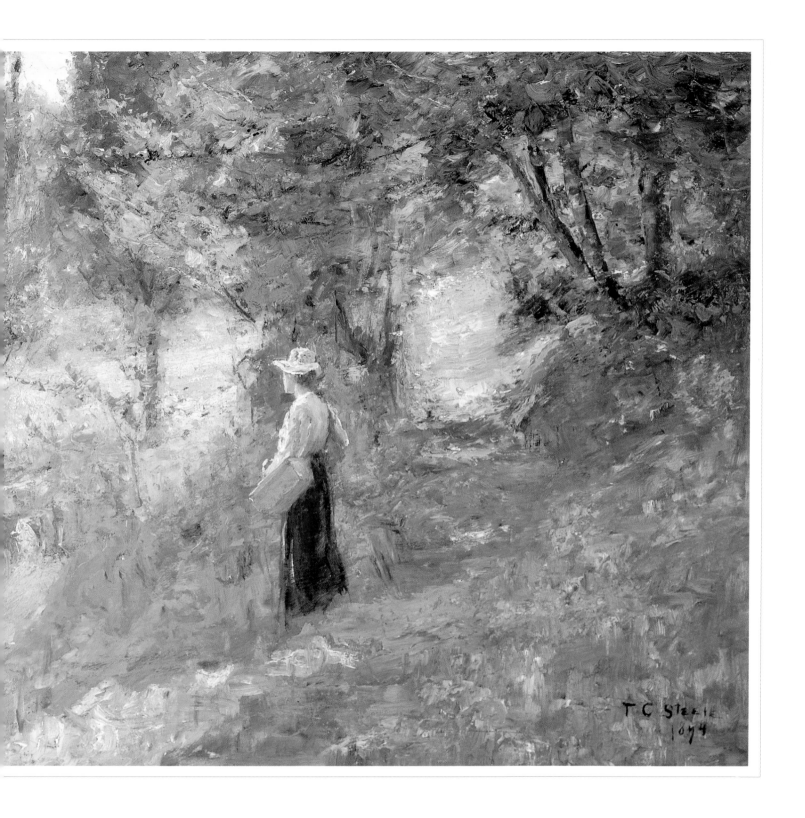

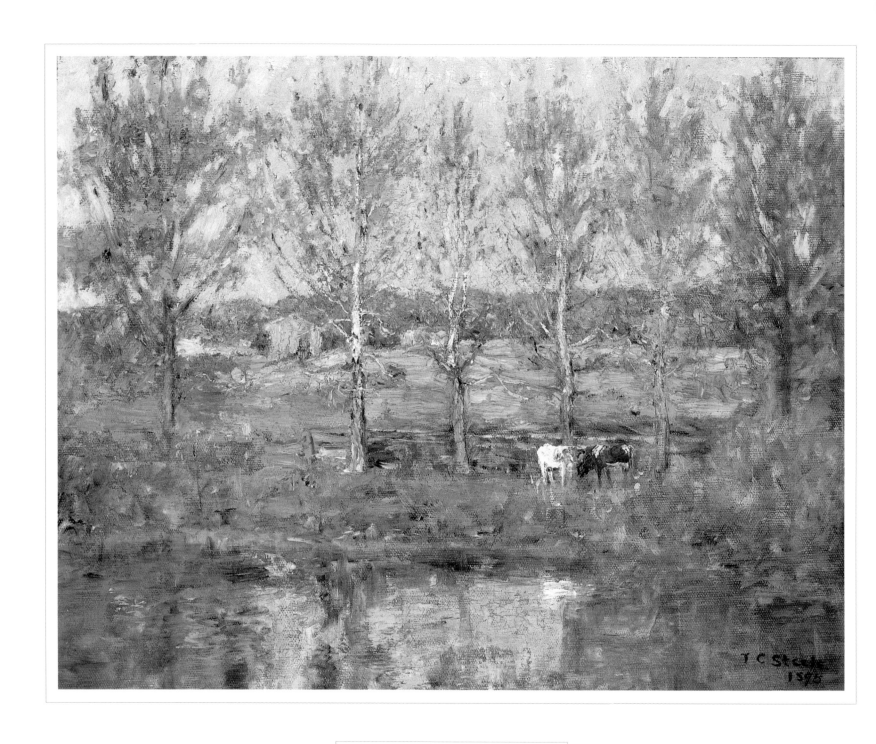

COWS BY THE STREAM, 1895
Oil on canvas, 16 x 23 inches
Collection of Mark and Carmen Holeman

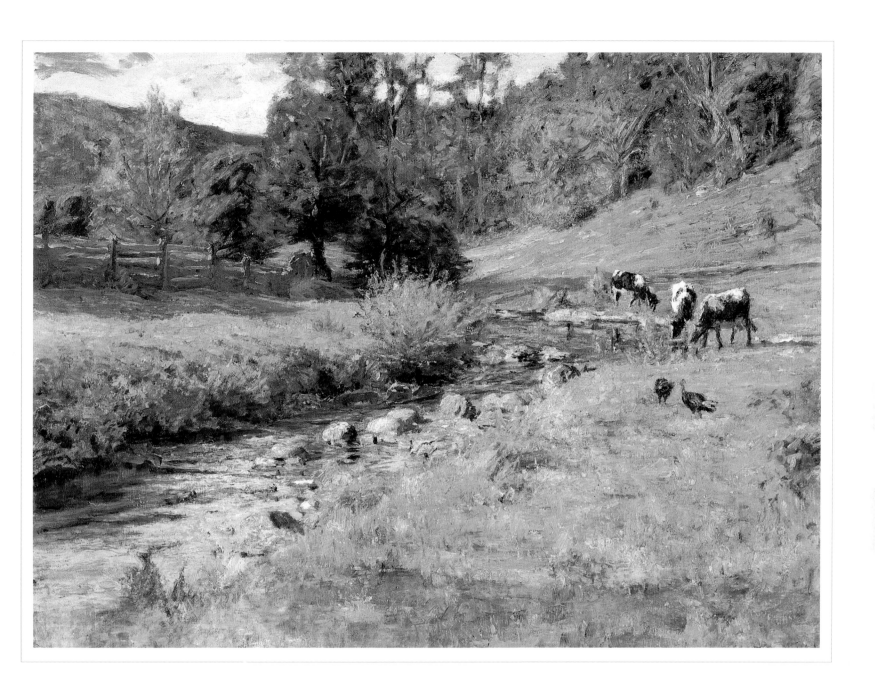

TENNESSEE SCENE, 1899
Oil on canvas, 22 x 29 inches
Private collection

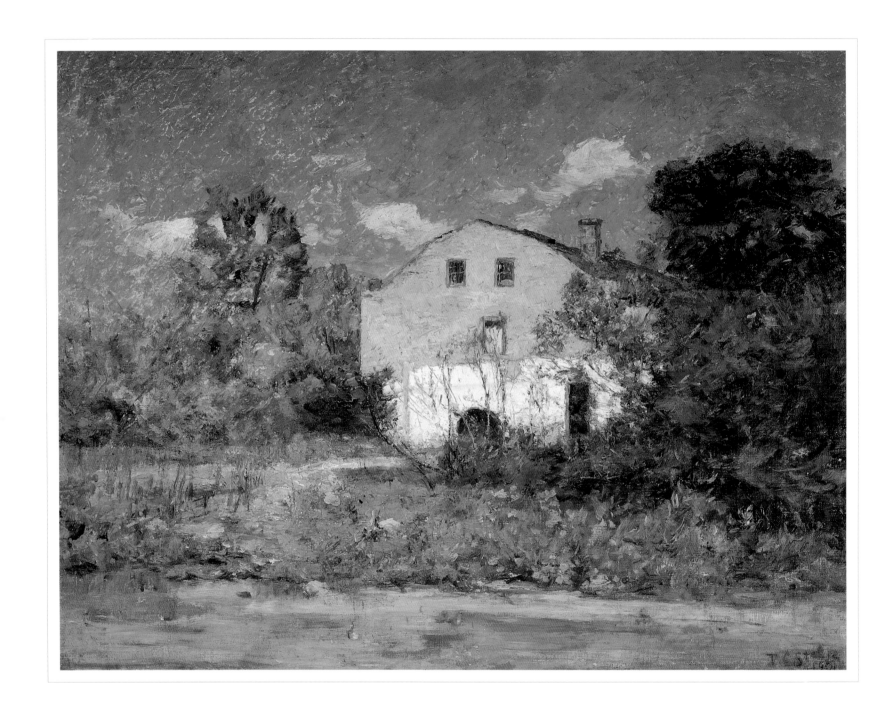

The Grist Mill, 1901
Oil on canvas, 21 1/2 x 26 1/2 inches
Private collection

STREET SCENE, 1896
Oil on canvas, 16 x 23 inches
Collection of Bob and Ellie Haan

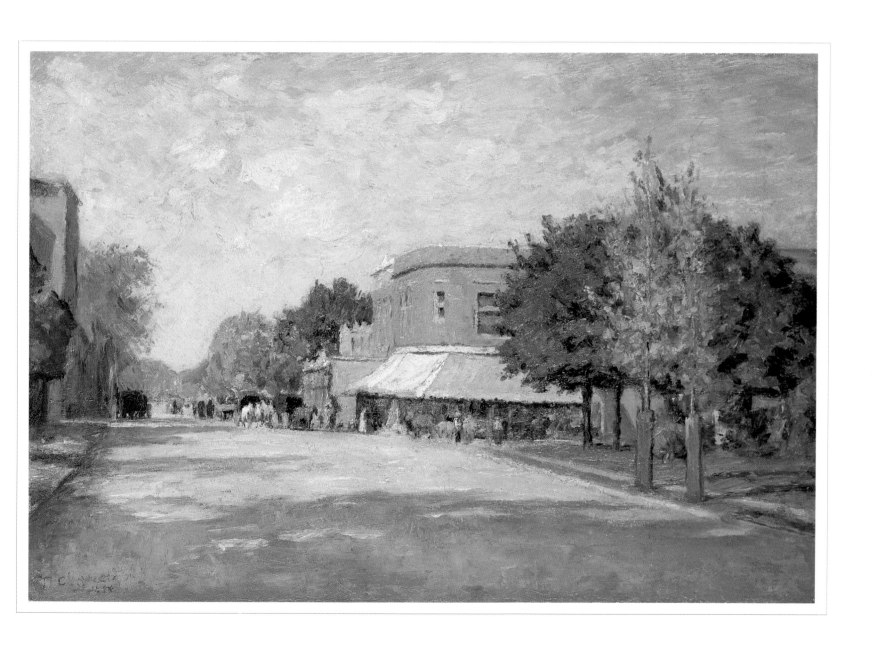

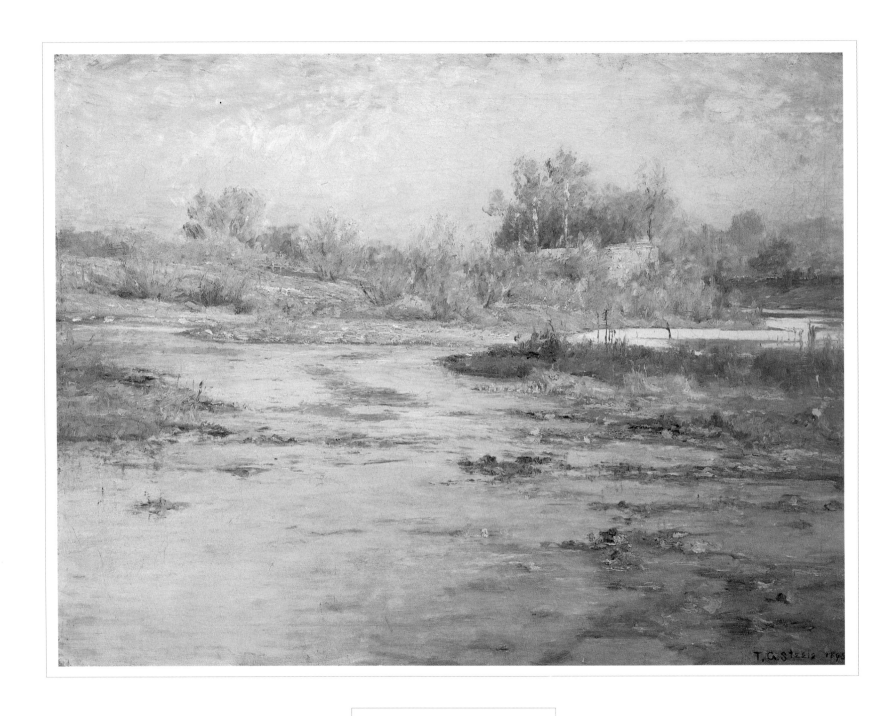

Mysterious River, 1895
Oil on canvas, 22 x 29 inches
Collection of Bob and Ellie Haan

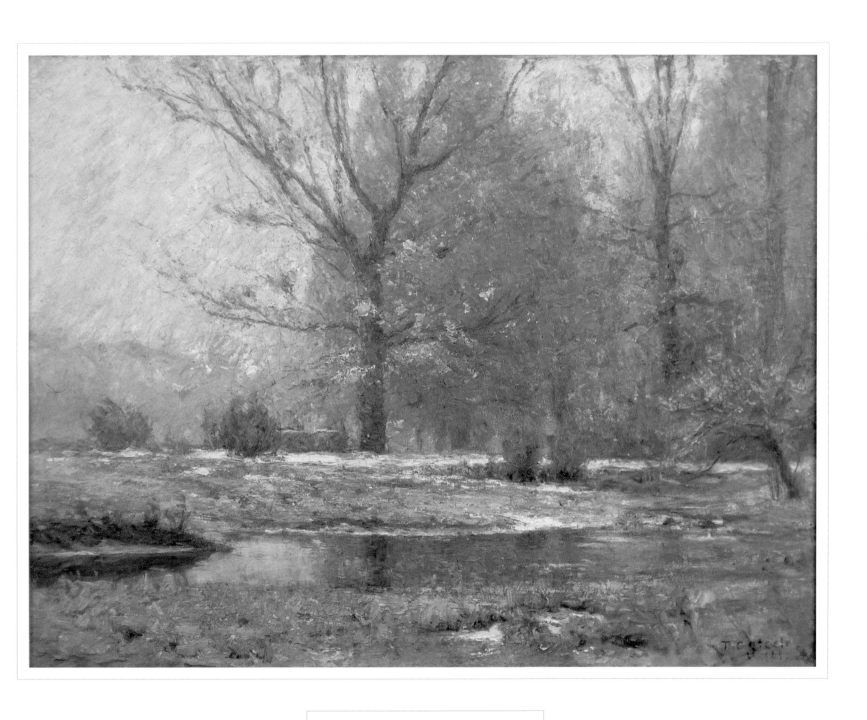

CREEK IN WINTER, 1899
Oil on canvas, 22 x 29 inches
Collection of Mr. and Mrs. James W. Emison, III

59

FLOWER GARDEN AT BROOKVILLE, 1901
Oil on canvas, 13 x 18 inches
Private collection

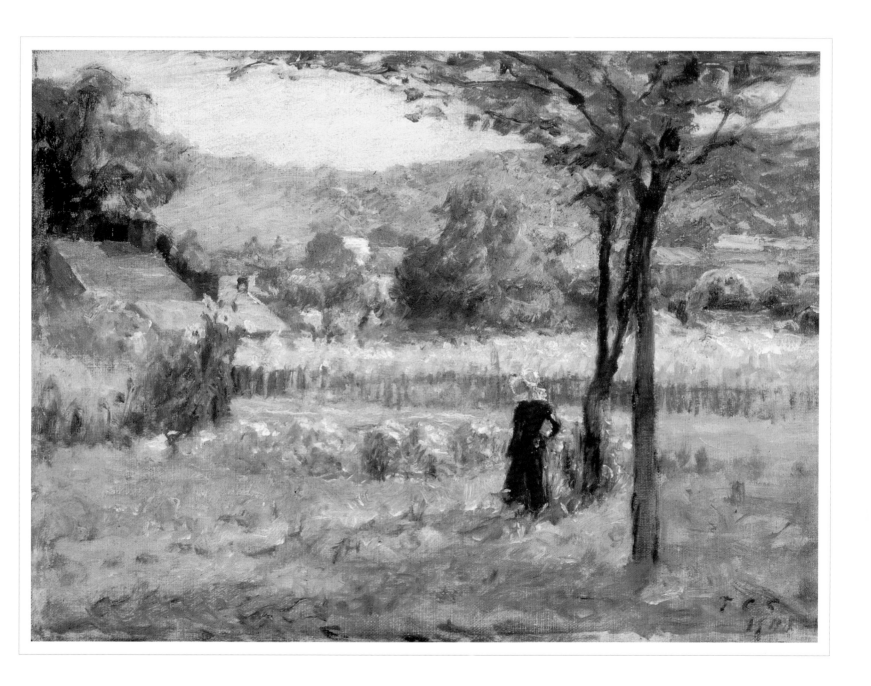

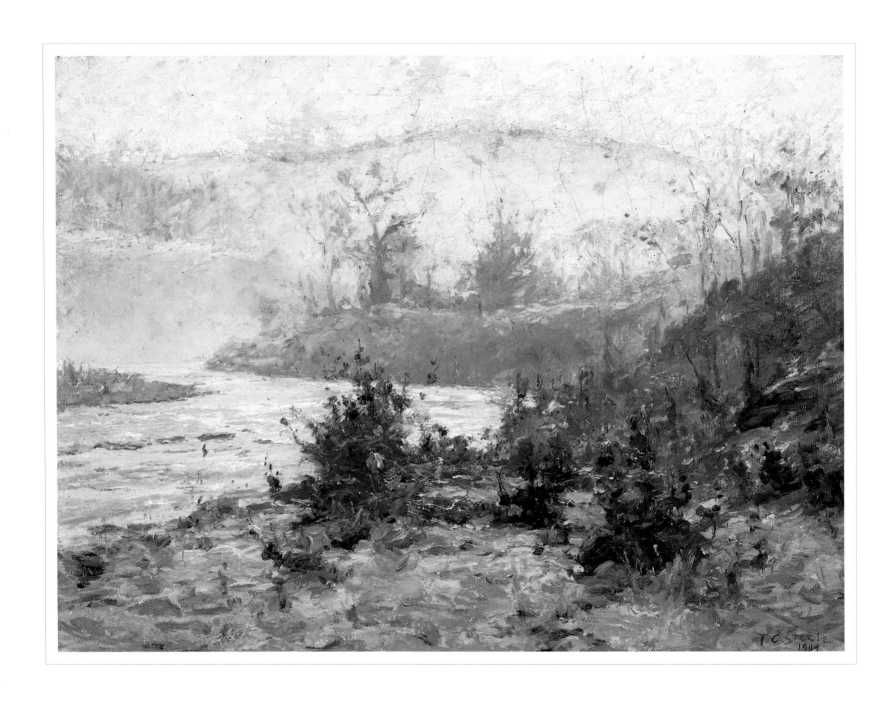

Whitewater River, 1904
Oil on canvas, 22 x 29 inches
Collection of Dana Reihman and Eileen Cravens

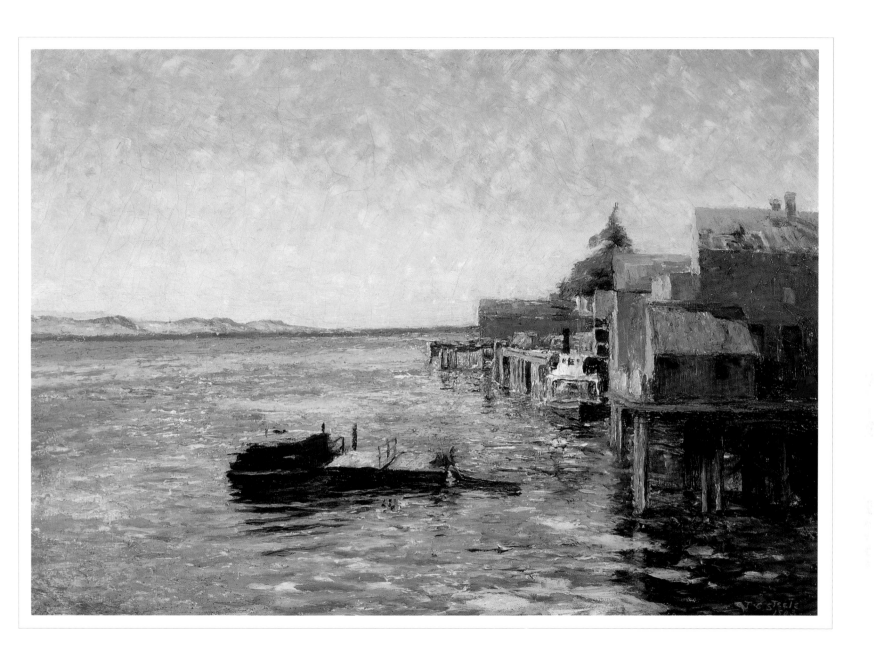

Puget Sound, 1903
Oil on canvas, 20 x 24 inches
Collection of Eugene L. and Mary L. Henderson

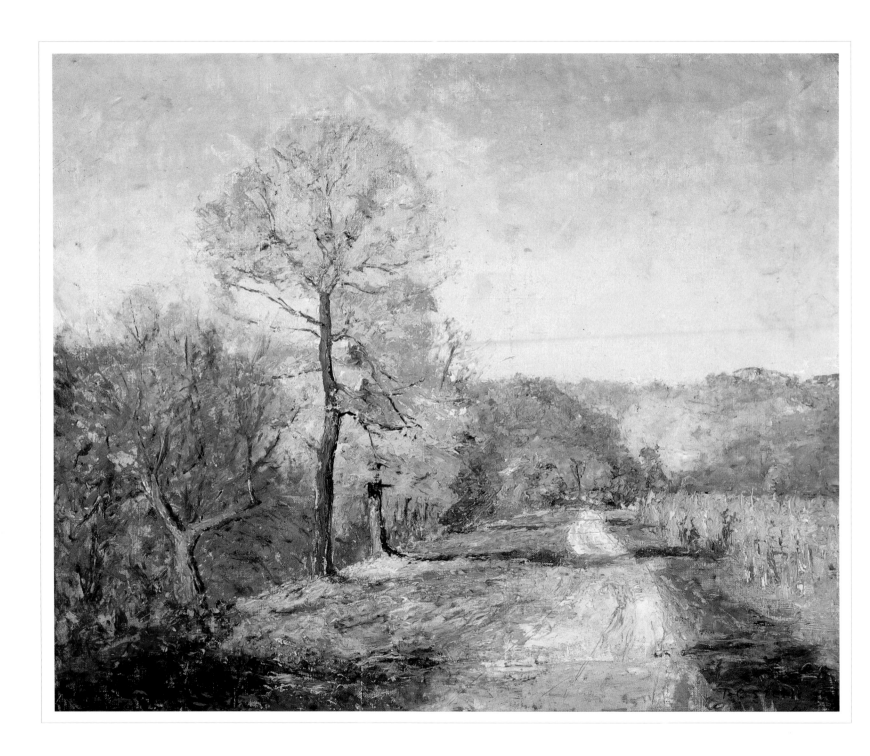

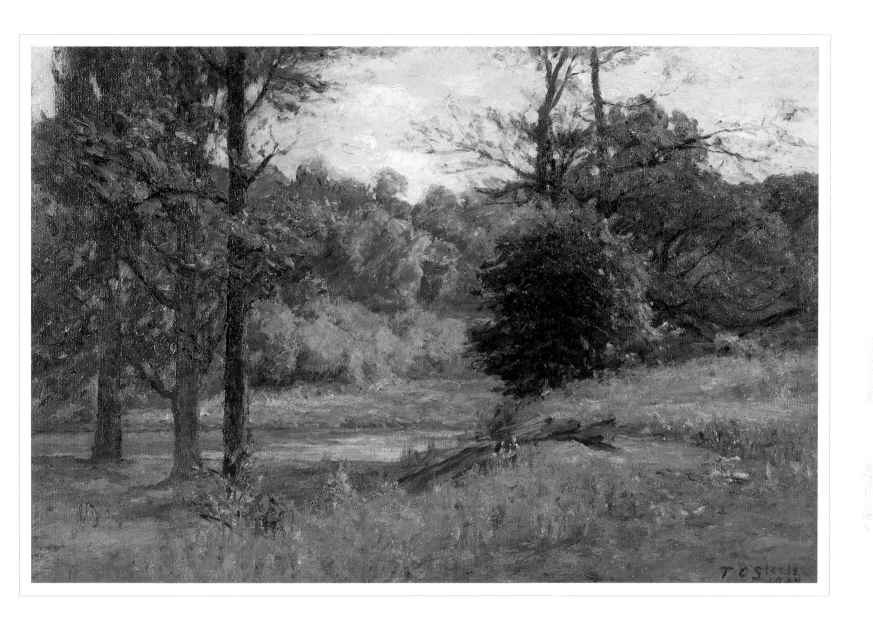

ALONG A COUNTRY LANE, 1901
Oil on canvas, 20 x 24 inches
Collection of Eckert Fine Art, Indianapolis, Indiana

ALONG THE CREEK (ZIONSVILLE), 1905
Oil on canvas, 22 x 32 inches
Collection of George Koch Sons, Inc., Evansville, Indiana

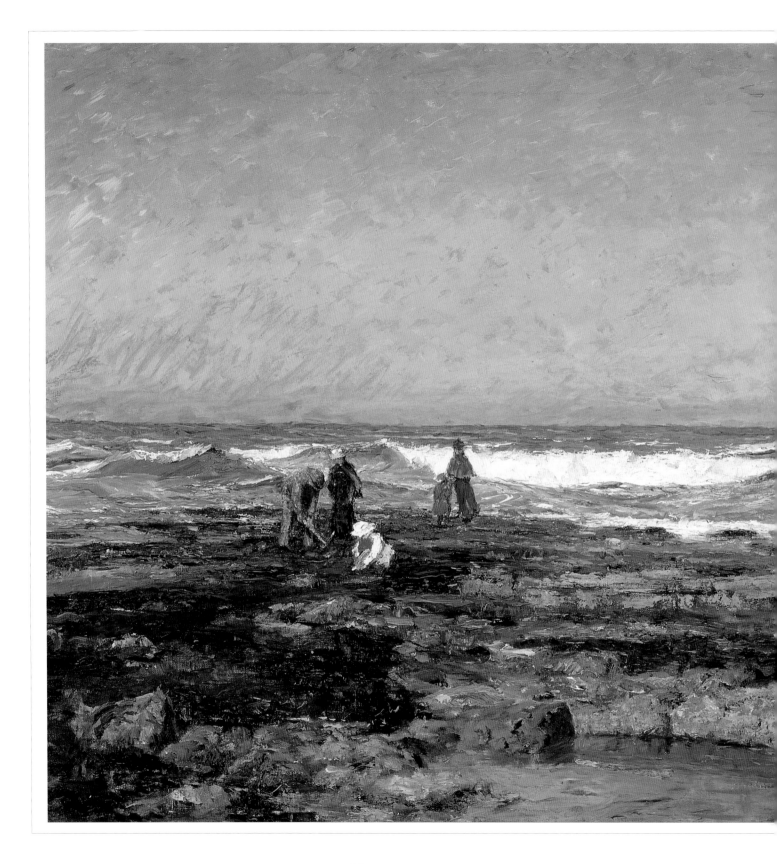

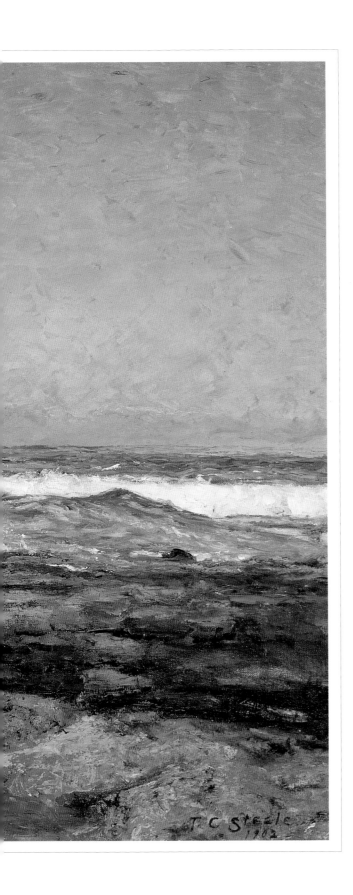

Clam Diggers, 1902
Oil on canvas, 22 x 32 inches
Private collection

OREGON COAST, 1903
Oil on canvas, 16 x 20 inches
Collection of Jane and Andrew Paine

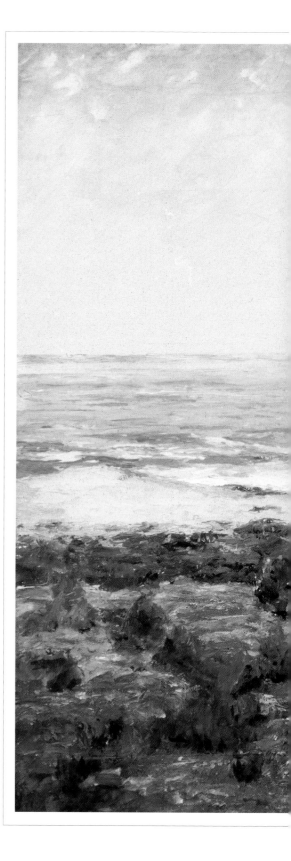

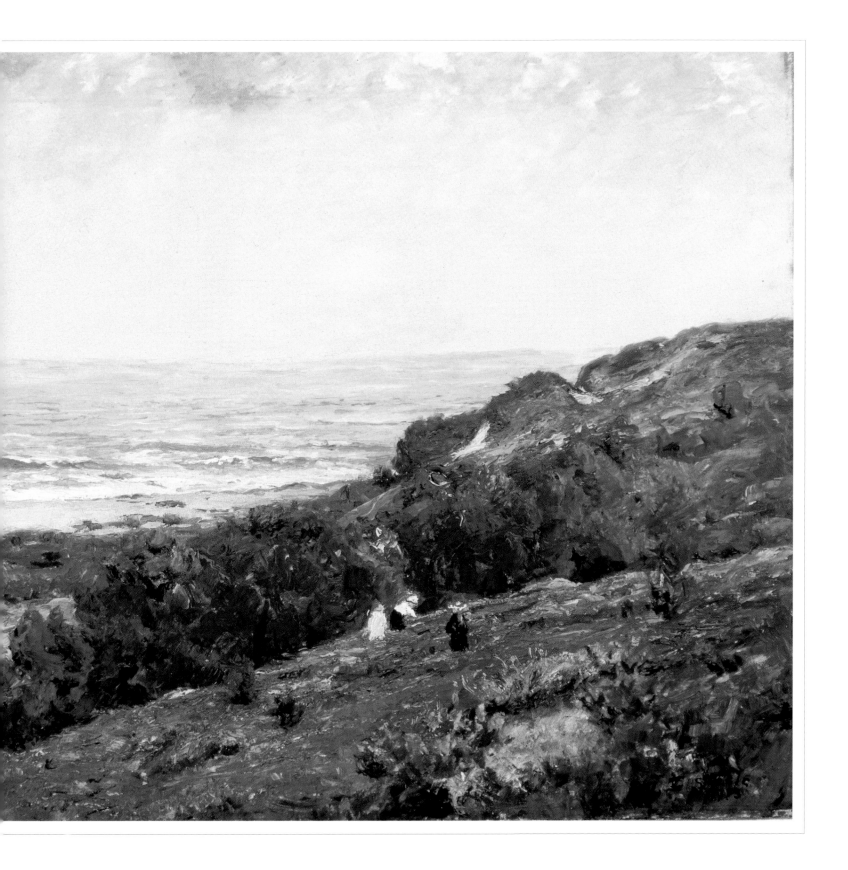

The Poplars, 1914
Oil on canvas, 48 x 56 inches
Collection of Jane and Andrew Paine

LAST HOUR OF THE DAY, 1916
Oil on canvas, 30 x 40 inches
Collection of George Koch Sons, Inc., Evansville, Indiana

HOUSE OF THE SINGING WINDS, 1922
Oil on canvas, 30 x 40 inches
Collection of Eckert Fine Art, Indianapolis, Indiana

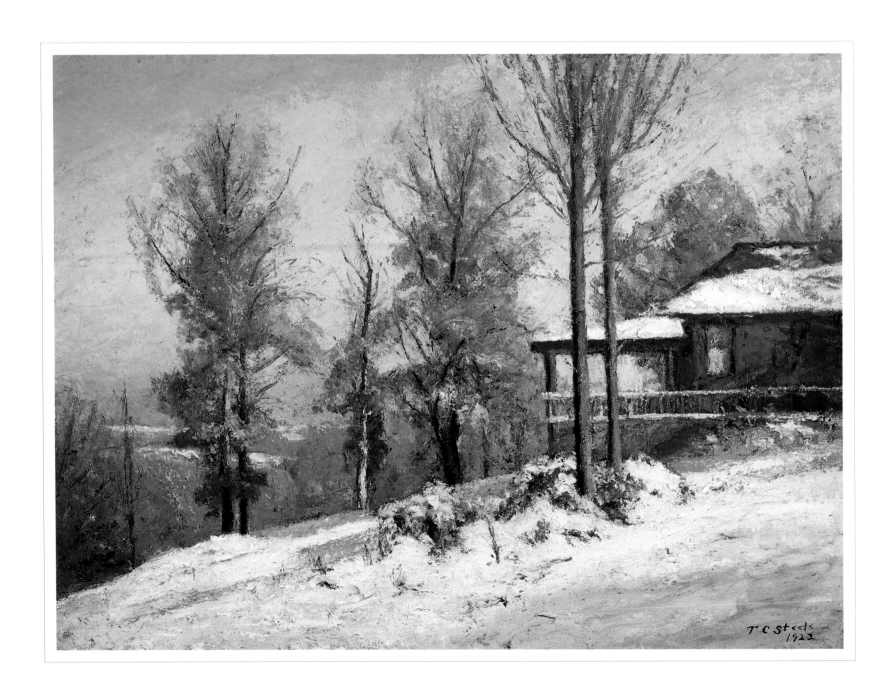

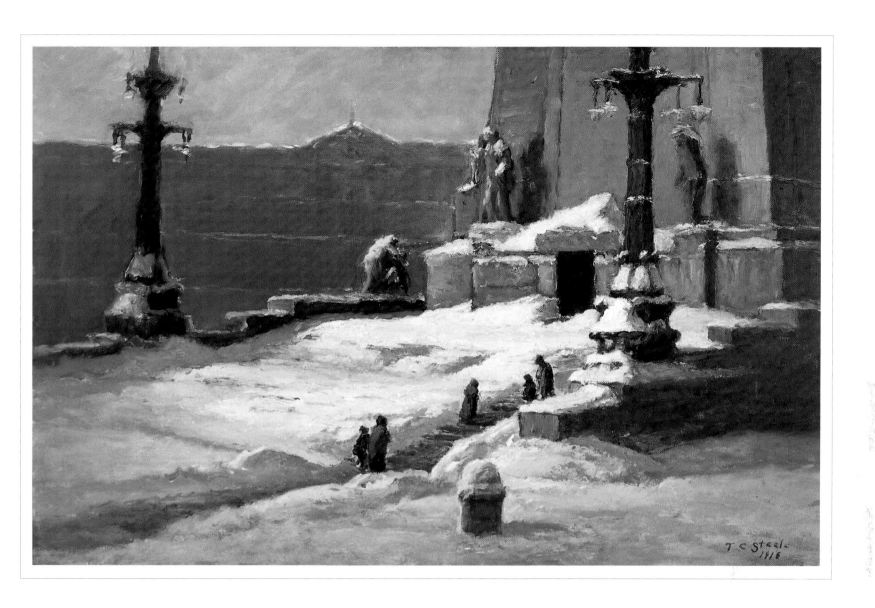

MONUMENT IN THE SNOW, 1918
Oil on canvas, 24 x 36 inches
Collection of the Indiana State Museum and Historic Sites
Indianapolis, Indiana

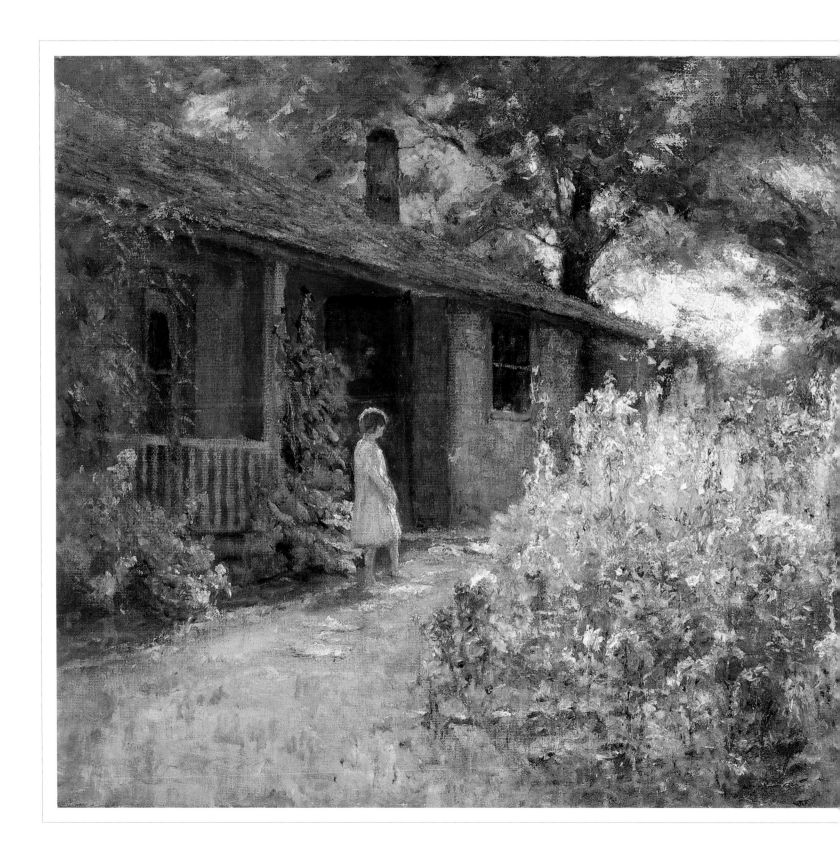

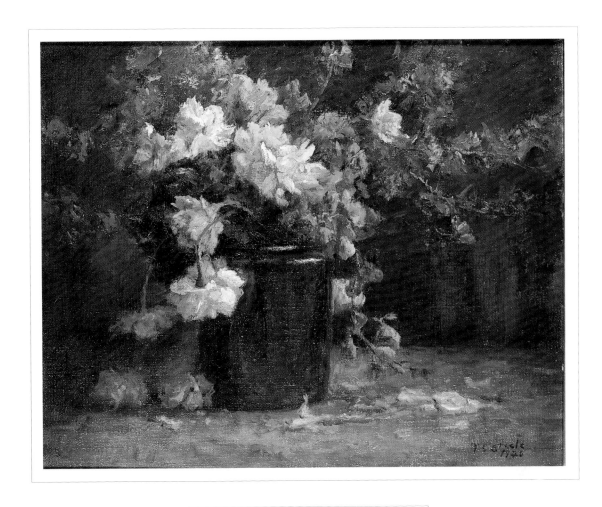

JUNE GLORY, 1920
Oil on canvas, 20 x 24 inches
Collection of Mr. and Mrs. Wade C. Harrison
Attica, Indiana

CHILD WITH FLOWERS, 1918
Oil on canvas, 30 x 40 inches
Private collection

75

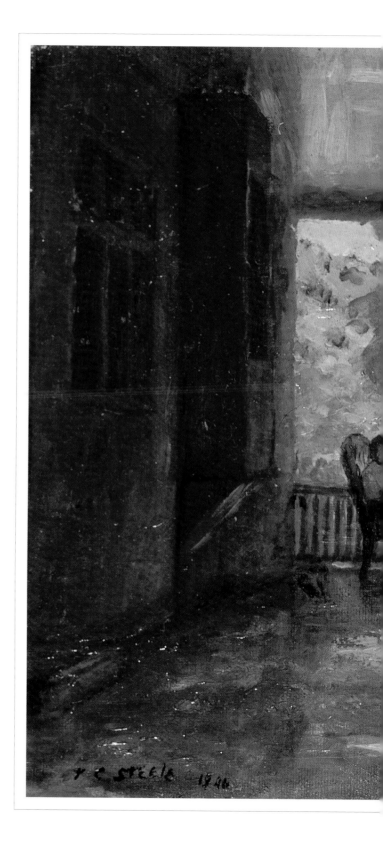

WOMEN ON THE PORCH, 1899
Oil on canvas, 15 x 22 inches
Collection of Bob and Ellie Haan

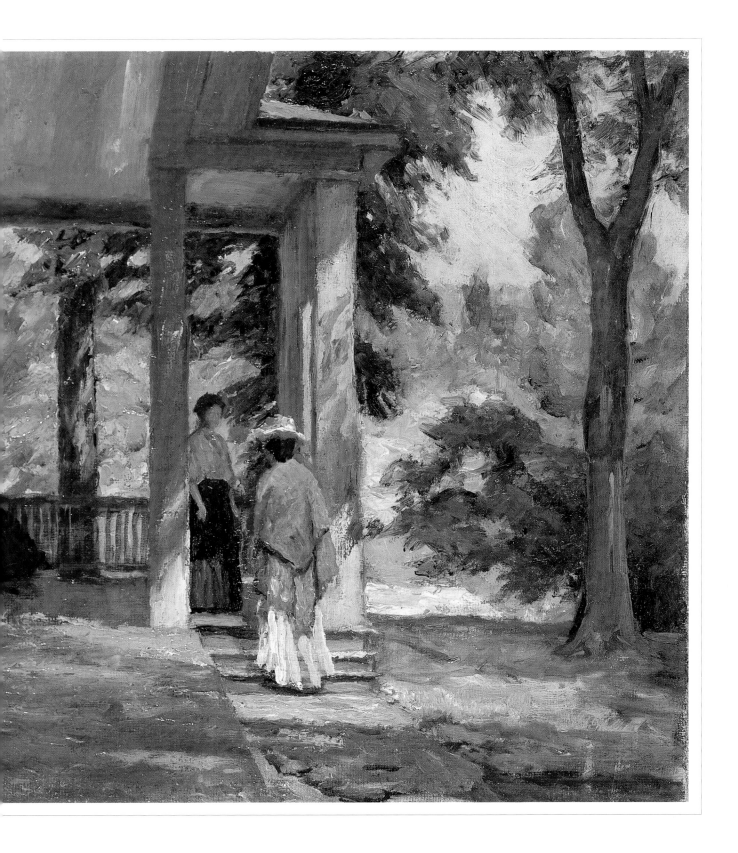

BIOGRAPHICAL CHRONOLOGY

1847 Theodore Clement Steele is born on September 11, near Gosport, Indiana.

1852 Steele family moves to Waveland, Indiana.

1859 Steele enrolls in Waveland Collegiate Institute where he receives first formal instruction in art.

1860 Begins teaching drawing at Waveland.

1861 Begins painting portraits in oil.

1863 Studies painting with Joseph Tingley, Professor of Natural Science, Asbury College, Greencastle, Indiana.

1868-1869 Graduates, June 1868, from Waveland Collegiate Institute; continues study of art in Cincinnati and Chicago.

1870 Marries Mary Elizabeth (Libbie) Lakin; moves to Battle Creek, Michigan; son, Rembrandt (Brandt) Theodore, is born.

1872 Daughter, Margaret (Daisy), is born.

1873 Steele family moves to Indianapolis, Indiana, where Steele establishes portrait studio.

1877 Founds Indianapolis Art Association with John W. Love.

1878 Second son, Shirley Lakin, is born.

1880 Steele enrolls in Royal Academy, Munich, Germany; studies drawing in Gyula Benzcur's nature class.

1881 Admitted "conditionally" to Ludwig von Loefftz's technical painting class; paints landscapes with American expatriate J. Frank Currier while summering in Schlessheim, where the Steele family settles in October.

1882 Admitted to Loefftz's class; Steele takes rooms at Mittenheim Cloister in June; returns to Schleissheim in December.

1884 Awarded silver medal for *The Boatman* at Royal Academy's annual student competition.

1885 Art Association of Indianapolis sponsors "Ye Hoosier Colony in München," an exhibition of paintings by Steele and William Forsyth; Steele family returns to Indianapolis and leases Tinker Place where Steele establishes a portrait studio.

1886 Builds studio on Tinker Place grounds; spends autumn painting season at Vernon on the Muscatatuck River.

1887 Paints portraits and landscapes near Ludlow and Cavendish, Vermont.

1888 Paints near Yountsville, Montgomery County, Indiana.

1889 Nominated for United States Consul in Munich; opens Indiana School of Art in Indianapolis; paints landscapes in Indianapolis and Montgomery County.

1890 Publishes The Steele Portfolio; paints with Forsyth at Vernon; Steele and his wife Libbie founding members of the Portfolio Club in Indianapolis.

1891 Resigns as director of Indiana School of Art; continues teaching day and evening classes; summers at Vernon, where he paints with Forsyth.

1892 Summers at Vernon, where he paints with Forsyth.

1893 Exhibits at Columbian Exposition, Chicago, Illinois; paints with Harry Grant Williamson at Vernon in October.

1894 Paints at Vernon from early August through September; "Exhibit of Summer Work by T. C. Steele, William Forsyth, R. B. Gruelle and Otto Stark," sponsored by the Art Association of Indianapolis; Chicago exhibition, "The Hooser Group," with added works by John Ottis Adams, sponsored by the Central Art Association at the sculptor Laredo Taft's studio.

1895 Resigns from Indiana School of Art; paints at Spencer during summer at Black's Mill on the Mississinewa River with Adams and Henry McGinnis in October and November.

1896 Steele, Forsyth, and Adams founding members of the Society of Western Artists; Steele elected vice-president of the Art Association of Indianapolis; dedicates much of the year to painting portraits; paints at Metamora with Adams and McGinnis in October and November.

1897 Steele and Adams paint at Metamora in late summer and travel down the Whitewater River to Brookville in October.

1898 Steele and Adams purchase The Hermitage in Brookville; Steele elected president of the Society of Western Artists.

1899 Steele serves on American selection committee of Paris Universal Exposition; summers in Tennessee in the Cumberland Mountains; wife Libbie dies in November of tuberculosis.

1900 Awarded honorable mention, Paris Universal Exposition; receives honorary masters degree from Wabash College, Crawfordsville, Indiana; paints at The Hermitage with Adams, Forsyth and Stark.

1901 Paints at The Hermitage with Adams, Forsyth and Stark during late summer.

1902 Travels to Oregon and California with his daughter Daisy from July until mid-November.

1903 Returns to West Coast with Daisy; serves on the jury of selection for

1904 World's Fair—Louisiana Purchase Exposition—in St. Louis, Missouri.

1904 Exhibits and serves on jury of awards for the Lousiana Purchase Exhibition; paints at The Hermitage during the summer.

1905 Exhibits in one-artist show at Pratt Institute, Brooklyn, New York; paints in Zionsville, Indiana, and at The Hermitage.

1906 Travels to Brown County, Indiana.

1907 Sells his interest in The Hermitage to Adams and purchases land in Brown County where he builds The House of the Singing Winds; marries Selma Neubacher; paints in Brown County from mid-August through mid-November; exhibits in one-artist show at the St. Louis Art Museum, St. Louis, Missouri.

1908 Begins regular schedule of painting in Brown County from early spring through late fall; winters in Indianapolis.

1910 Exhibits in one-artist retrospective at the John Herron Art Institute, Indianapolis, and at the International Exhibition of Fine Arts in Buenos Aires, Argentina, and Santiago, Chile.

1912 Paints in Brown County from early February until late spring and intermittently through summer and fall.

1913 Elected to National Academy of Design as associate member.

1914 Paints landscape murals for City Hospital, Indianapolis; serves on jury of selection, Department of Fine Arts, Panama-Pacific International Exposition.

1915 Exhibits at Panama-Pacific International Exposition, San Francisco, California.

1916 Builds large studio at The House of the Singing Winds; receives honorary doctorate from Indiana University, Bloomington.

1918 Contracts rheumatic fever in summer and is unable to paint until August 1919.

1922 Appointed artist-in-residence at Indiana University; establishes campus studio.

1925 Suffers heart attack in December.

1926 Theodore Clement Steele dies on July 24 at The House of the Singing Winds; memorial exhibition held at John Herron Art Institute.

SELECTED BIBLIOGRAPHY

Art Association of Indianapolis: A Historical Sketch. Indianapolis: Art Association of Indianapolis, 1989.

Brooks, Alfred Mansfield. "The Art and Work of Theodore Steele." *American Magazine of Art* 8 (August 1917): 401–406.

———. "The House of the Singing Winds." *American Magazine of Art* 11 (February 1920): 139–141.

Browne, Charles Francis, Hamlin Garland, and Lorado Taft. *Five Hoosier Painters.* Chicago: Central Art Association, 1894. Excerpted in "Five Hoosier Painters," *The Arts* 3 (January 1895): 179–184.

Burnet, Mary Q. *Art and Artists of Indiana.* New York: Century Company, 1921.

———. "Indiana University and T. C. Steele." *American Magazine of Art* 15 (November 1924): 587–591.

Creveling, Thomas Lakin. *A Vision: The Portraiture of Theodore Clement Steele.* Evansville: Evansville Museum of Arts & Science, 1992.

Gerdts, William H. and Judith Vale Newton, *The Hoosier Group: Five American Painters.* Indianapolis: Eckert Publications, 1985.

Graf, Josephine A. "The Brown County Art Colony." *Indiana Magazine of History 35* (December 1939): 365–370.

Krause, Martin. *The Passage: Return of Indiana Painters from Germany, 1880–1905.* Bloomington: Indiana University Press, 1990.

———. *Realities and Impressions: Indiana Artists in Munich, 1880–1890.* Indianapolis: Indianapolis Museum of Art, 1985.

Letsinger-Miller, Lyn. *The Artists of Brown County.* Bloomington: Indiana University Press, 1994.

Memorial Exhibition: Theodore C. Steele, 1847–1926. Indianapolis: 1926.

Peat, Wilbur D. *Pioneer Painters of Indiana.* Indianapolis: Art Association of Indianapolis, 1954.

Psi Iota Xi Sorority. *Brown County Art and Artists.* Nashville, Indiana: Brown County Art Gallery Association and Brown County Art Guild, 1971.

Shulz, Adolph Robert. "The Story of the Brown County Art Colony." *Indiana Magazine of History* 31 (December 1935): 282–289.

Steele, Mary Elizabeth. *Impressions.* Indianapolis: Portfolio Club, 1893.

Steele, Selma N., Theodore L. Steele, and Wilbur D. Peat. *The House of the Singing Winds.* Indianapolis: Indiana Historical Society, 1966; new edition 1989.

Steele, Theodore Clement. "Impressionism." *Modern Art* 1 (Spring 1893).

———. "The Mark of the Tool." *Modern Art* 2 (Spring 1894).

———. *The Steele Portfolio.* Indianapolis, 1890.

Sturtevant, Mabel. "Theodore Clement Steele." *Hoosier Magazine* 1 (February 1930): 20–21, 36–37, 48–50.

T. C. Steele: Indiana Painter, 1847–1926. Fort Wayne: Fort Wayne Museum of Art, 1967.

"T. C. Steele." *New Era.* Indiana Artists Series (16 March 1912).

The Best Years: Indiana Paintings of the Hoosier Group, 1880–1915. Indianapolis: Indiana State Museum, 1985.

Theodore Clement Steele: Reflections. Indianapolis: Eckert Publications, 1991.

The Steele Papers. Lectures. Archives of American Art, Smithsonian Institution, Washington, D. C.

Lectures include "The Trend of Modern Art," delivered at the Convention of Indiana Union Literary Clubs, May 1895; "The Art of Seeing Beautifully" at the Fort Wayne Art School and Museum, December 1925; "In the Far West" (1903) and "The Value of Beauty," at the Portfolio Club of Indianapolis; and "Impressionism."

"Visit to The Hermitage." *Indianapolis News* (7 September 1901).

White, Nelson C. *The Art and Life of J. Frank Currier.* Cambridge: privately printed, 1936.

William Forsyth. *Art in Indiana.* Indianapolis: Eckert Publications, 1991.

Ye Hoosier Colony in München. Indianapolis: Art Association of Indianapolis, 1885.

PAINTINGS IN THE EXHIBITION

OTHER ILLUSTRATIONS